HOW TO *show & share your*

DIGITAL

photographs

HOW TO *show & share your* DIGITAL *photographs*

GRAHAM DAVIS

TED SMART

contents

This edition produced for
The Book People Ltd,
Hall Wood Avenue,
Haydock,
St Helens,
WA11 9UL

This book was conceived by
ILEX
Cambridge
England

British Library Cataloguing-in-Publication Data
A catalogue record for this book is available
from the British Library

For more information on this title please visit:
www.prdpuk.web-linked.com

Printed and bound in China

introduction

In the days before digital photography, life seemed simple – film was processed into either prints or transparencies, and for the well organized, prints were stored in albums or transparencies viewed via slide projector. For many, however, the task was too onerous and the shoe box was where the photographic collection ended up. The advent of digital photography has been liberating; every week millions of digital images are created, some to be printed and displayed, but many, however, are lost in the digital equivalent of that shoe box. *How to Show and Share Your Digital Photos* is packed full of suggestions on how to organize, present and share your digital photographs.

Creating your own family tree, a poster of a day trip, fun borders or personalized birthday cards are all easy to achieve – just follow the simple step-by-step instructions.

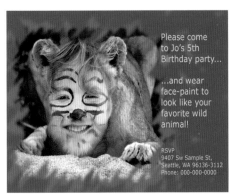

What You'll Learn

For many, digital camera technology is rife with baffling jargon that is hard to fathom. Section 1 – *Hardware and Software* – converts the jargon into plain English. Here we offer advice on what to look for in cameras, scanners, computers, printers and software – from how many megapixels you need, through what computing power is required, to what software applications are appropriate.

In section 2 – *Getting Started* – you'll learn how to transfer photos from your camera (or scanner) to a computer, with advice on how to organize picture files and copy them onto CD or DVD.

Before you get to the projects themselves, in section 3 – *Image Editing and Printing* – we'll show you how applications like Adobe's Photoshop Elements have made photo retouching and enhancement available to the amateur. You'll learn about the basic menus and tools used in image editing, and how they can be used to

correct exposure or colour, crop or resize images, even how to sharpen soft-looking images and get rid of annoying 'red-eye'. This section also explains about layers. Learning how to use layers is an essential part of image editing, and almost all the projects contained in this book use them. You'll be amazed at how easy they are to master. Finally, section 3 finishes with information on printing. Even inexpensive inkjet printers offer staggering print quality and most will accept the various media we've used in the creation of the projects; however, it's important to know what the best settings are to avoid disappointing results. We also provide information on getting images printed professionally if there's something you can't do at home, such as impressive, poster-size prints.

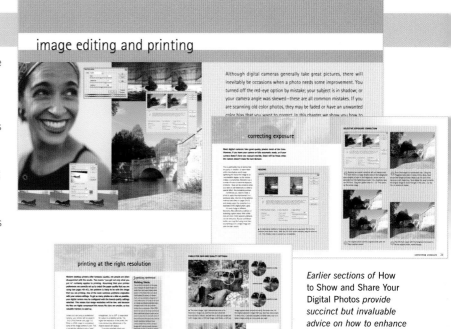

Earlier sections of How to Show and Share Your Digital Photos *provide succinct but invaluable advice on how to enhance your photos – and there's even information on how to prepare your images for the Web.*

The Projects

We begin the projects in section 4 – *Print Projects* – where you'll be given step-by-step instructions on how to create a variety of fun and practical ideas, ranging from a personalized birthday invitation to designing stationery. Each project is carefully devised to present digital photographs in a different way.

Section 5 – *Special Print Projects* – again shows you how to use digital photos in new and exciting ways. In this section we'll explain how to make your own sticky labels, to print onto t-shirts, and even how to produce fun items such as fridge magnets. There's really no end to your creative options.

In section 6 – *Screen Projects* – we concentrate on how the Internet can help you to share photos. Nowadays most people have an Internet connection and email, and here we cut through the jargon to help get your photographs online. There are two main options available; to create projects on your home computer and then transfer them to the Web space that nearly all Internet service providers (ISPs) provide, or to use an online service to assemble the images into a photo gallery, slideshow or even a website – *How to Show and Share Your Digital Photos* includes creative and achievable projects for both options. Finally, section 7 – *Reference* – is packed with helpful

advice, Web addresses and details of the unique website (*see page 166*) that accompanies this title, and which is available to all purchasers of *How to Show and Share Your Digital Photos*. Log on to the site and you'll be able to download the borders and templates used in the creation of some of the projects, along with helpful links to other relevant online resources.

The combination of digital cameras, computers, storage devices like CD and DVD and the Internet offer an unprecedented opportunity for all of us to create and share a visual record of our lives with friends and family – wherever they live. This book will help you make such a record.

hardware and software

Photo Story

:come to Plus! Photo Story

Plus! Photo Story helps you to create exciting video stories by adding panning and zooming motions to your still pictures.

Use Photo Story to record narration for your pictures, add a title page and backgroun music, and automatically save your story to Media Library in Windows Media Player.

PhotoImpact - NY scenel.JPG

File Edit View Format Selection Object Effect Web Window Help

Font Size Style Alignment Color Mode Material Pan Add
Arial 24 B I U T T 2D Object

NY scenel.JPG (28%) 2311x1526

Painting Gallery - EasyPalette (Read-only)

Fill Gallery
Effect Gallery
Style Gallery
Painting Gallery
Brush Gallery
Stamp Gallery
Particle Gallery
Lighting Gallery
Animation Gallery
Material Attribute
Material Gallery

Brick Corrugated Cru

The explosion of interest in digital photography in recent times has brought about a vast number of new products and manufacturers – not just in terms of cameras, which have seen electronics companies competing with traditional camera manufacturers – but also in terms of digital-imaging software, printers, scanners and many other accessories. Before you buy any photographic or computer equipment, it is sensible to do some research. If you are reasonably experienced and know what you want, this is simply a case of getting the best deal. If you are less sure, this chapter establishes some ground rules for you to follow. We cannot recommend specific products or brands. However, there are several organizations that offer impartial advice and product reviews in a constantly changing marketplace. Their Web addresses are listed on page 167.

CHAPTER CONTENTS

'capturing' your photos

The projects contained in this book rely on you being able to 'capture' photographs digitally – that is, you need to able to create digital picture files that can be stored on a computer. There are two ways of doing this. One is to buy a digital camera, take your photos and then transfer the picture files to the computer. Another is to scan existing photographs using a scanner; this converts your photo into a digital file, which in turn can be placed on the computer. Here we offer some basic advice on cameras and scanners.

This Fuji FinePix S5000 is a 3MP camera designed to look and feel like a single lens reflex camera.

COMPARATIVE IMAGE SIZE VS MEGAPIXELS (MP)

An image from a 3MP camera printed at 300dpi on an A4 piece of paper

An image from a 4MP camera printed at 300dpi on an A4 piece of paper

An image from a 6MP camera printed at 300dpi on an A4 piece of paper

Choosing a digital camera

When deciding what camera to buy, one of the key things to look for is the number of megapixels (MP) the camera has. All digital images are made up of individual picture elements ('pixels'). The higher the number of pixels, the better the image quality. Today, megapixel values range from 1MP to 8MP. As a general rule of thumb, 1MP is sufficient only if your images will be viewed on a computer. If you want to make photo-quality prints, then you really need a camera with a minimum of 3MP. The chart on the left shows the relative size of photo-quality prints that can be obtained with varying megapixel counts.

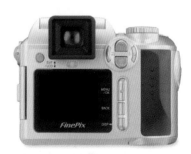

The back of a typical compact digital camera, showing various menu and control buttons.

Of course, image quality is also governed by the quality of the lens. Fortunately, the lenses found in modern compact cameras all tend to be of good quality, but if in doubt you can check the lens accuracy of most camera models on www.dpreview.com.

Another key consideration is the power of the optical zoom. Most compact cameras have a 3X or 4X zoom, which is adequate for most situations. Ignore the digital zoom figure, however, as images taken using the digital zoom will be of poor quality.

Memory cards and card readers

Your camera will come with a memory card on which to store the images. However, this will have a relatively small capacity and you won't be able to store many images on it. Buy a second card with a much larger capacity. This will be much more adequate for your needs (see the chart above right for guidance).

Images are usually transferred from the camera to the computer via

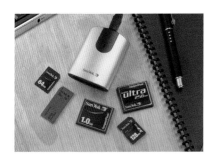

There is a variety of memory storage cards and card readers. The greater the capacity of the memory card, the more images you can fit on it. Make sure you know which type of card your camera takes – it may take more than one type.

✐ getting technical

Images stored on a memory card

Cameras vary in the range of quality options they offer. This chart is based on a typical mid-range 2.1 megapixel camera.

Memory card capacity	Low-quality images (64KB)	High-quality images (500KB)
16MB	250	32
32MB	500	64
64MB	1,000	128
256MB	4,000	512
512MB	8,000	1024

a special cable called a USB cable. Read the camera's manual carefully for full instructions. An alternative method is to connect a card reader to the computer. To transfer your images, simply remove the memory card from the camera, and insert the card into the card reader. This will launch software on the computer, which will show you how to copy the images from the card across to the hard disk on the computer.

There is a wide variety of memory card formats available. These are not usually interchangeable, so if you buy a card reader make sure that it is compatible with the memory card that fits your camera.

Scanners

If you intend to scan photographs, a mid-range or even a budget flatbed scanner (one with a flat piece of glass) will suffice – but check that it has a minimum resolution of 1200dpi (dots per inch). Ignore any figures quoting interpolated resolution. Interpolated resolution is what the scanner will guess at rather than actually scan.

If you want to scan transparencies or colour negatives, from which prints have been made, there are two options: a slide converter that fits over the lid of a flatbed scanner or a dedicated film scanner. Again, if you buy a film scanner ensure the resolution is no less than 1200dpi.

Another important figure to look for is 'bit depth' (the amount of colour information the scanner can interpret). For flatbed scanners, 24-bits is sufficient, but if you're scanning film, 36-bit is preferable.

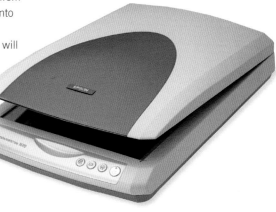

An example of a mid-range flatbed scanner, used for scanning colour photographs.

computers and printers

Having the right computer and printer enables you to undertake a variety of projects, from making a scrapbook to creating an online gallery. If you bought your computer no earlier than 2003, it is probably more than adequate for the projects shown in this book. If it's any older, use the checklist below to see how your model compares. And if you want photo-quality prints from your printer, we offer some basic advice here.

know your equipment

NEW COMPUTERS
Essential features

✔ USB2 or Firewire2 port (socket) – Both are backwardly compatible with USB(1) and Firewire(1) respectively. These offer the fastest connection from your camera, card reader or scanner to the computer.

✔ CD-R – 52x24x52x are the speeds for writing a CD-R, a CD-RW, and for reading an existing CD. A fast CD writer is well worth the little extra cost.

✔ DVD-R – 4x4x are the speeds for writing a DVD-R or a DVD-RW. For the presentation of still images, the cheaper CD-R will suffice. DVD-R is really only necessary if you intend to create home movies. A fast DVD writer will sell at a premium, as the technology is newer than CD-R.

Today's PCs will have more than enough processing power for your digital photo needs.

know your equipment

OLDER COMPUTERS
Specification checklist

✔ Does it have a USB connection?

✔ Does it have a minimum of 128MB of RAM?

✔ Does it have a hard disk in excess of 40MB?

✔ Does it have a CD-R to write (burn) CDs?

Computers

If your existing computer does not have the specifications outlined on the chart (left), you should consider replacing it. The choice is then between a Windows PC and an Apple Macintosh. Despite the devoted loyalty of some Mac aficionados, there is not much these days to chose between Macs and PCs. The PC is as easy to use as the Mac, and is considerably cheaper for a comparable specification. Even the entry-level computer has phenomenal power. Don't be persuaded to buy top-end kit, as you will not need it unless

you hope to graduate into professional digital photography.

If you buy a new computer, make sure that it has the features outlined on the new computer checklist (*page 12*).

An additional benefit of buying a new computer is that it will have the latest operating system. This is likely to offer you new features and increased functionality and ease of use.

Most new desktop computers come with either a 17-in conventional monitor or a 15-in flat screen. Both types normally display a resolution of 1024 pixels wide by 768 pixels deep. Portable notebook computers are popular, but they have the downside of smaller screens with lower resolution. They are also more expensive. Unless you really need a portable model, stick to a desktop model.

Printers

The quality achieved by modern colour printers is phenomenal. It can match the best photographic printing from film. There are two main technologies: inkjet and laser. The inkjet is by far the most popular with home users due to its low purchase cost. Colour laser printers used to be very expensive, but the prices are falling and may soon reach the level of the inkjet.

The running costs of inkjets are high, however. Most ink cartridges are expensive, and special paper must be used to obtain top quality printing. Colour laser cartridges are not cheap, but they last much longer than inkjet cartridges. Colour laser printers are also more tolerant of poorer quality paper.

⚙getting technical

How many colours?

Many inkjet printers and some colour laser printers use six or even seven colours to print an image. The quality is better than printers that use just four colours, particularly when printing photographs, but replacing ink cartridges is more expensive.

Most printers are limited to a maximum of A4 paper, although A3 prints are possible on some inkjets. Many inkjets boast a resolution of at least 1440dpi. Lasers are normally lower, at 600dpi. However, these figures are not directly comparable because each technology distributes the dots in a slightly different way.

Another important consideration is the range and weight (thickness) of paper or other media used in the printer. A list of the media used in this book can be found on page 44.

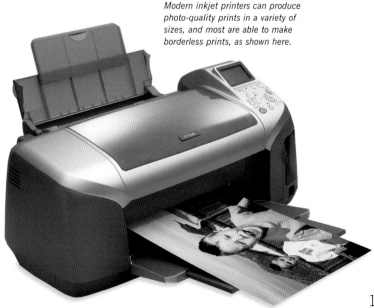

Modern inkjet printers can produce photo-quality prints in a variety of sizes, and most are able to make borderless prints, as shown here.

13

image-editing software

To present your digital photos, you will need image-editing software. This is often bundled with your digital camera or scanner. Adobe Photoshop Elements is particularly popular. It is inexpensive and, because it has been created specifically with the amateur photographer in mind, easy to use. There are many other software programs available to enhance, present and share your photographs, as a glance at any computer or digital photography magazine will reveal. Fortunately, most image-editing software uses a similar interface and set of tools. A variety of popular software application interfaces is shown opposite.

Selected from the Enhance *menu, the* Quick Fix *palette enables image improvements to be made with both the* Before *and* After *views visible.*

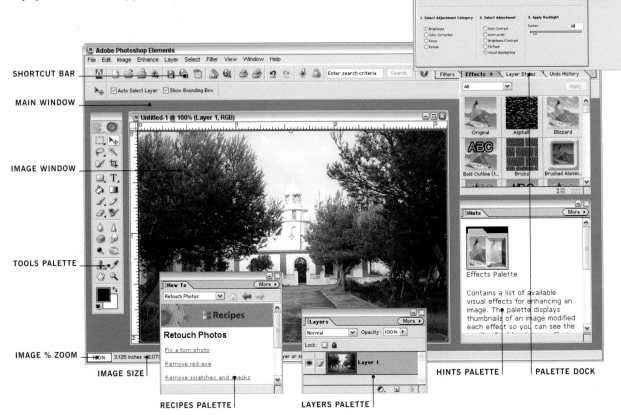

SHORTCUT BAR

MAIN WINDOW

IMAGE WINDOW

TOOLS PALETTE

IMAGE % ZOOM

IMAGE SIZE

RECIPES PALETTE

LAYERS PALETTE

HINTS PALETTE

PALETTE DOCK

Effects Palette

Contains a list of available visual effects for enhancing an image. The palette displays thumbnails of an image modified each effect so you can see the

Photoshop Elements is typical of many image-editing applications. It features 'recipes' that help you perform tasks such as Remove scratches and specks.

There are a great many image-editing programs available, and often, when you buy a new camera, scanner or printer, you will be given a free application.

For the projects in this book, we used Adobe Photoshop Elements, Microsoft MS Plus! Digital Media Edition and MS Moviemaker on a PC. Elements is available for both PCs and Apple Macintoshs. iPhoto and iMovie are options for the Mac.

File formats

In order to open a file in a particular software program, the file has to be recognized by that program. On a PC, the file is identified by its three-character file extension (the three letters after the full stop). For example, Photoshop Elements files have the file extension .psd. The file myphoto.psd can therefore be opened in Photoshop Elements. Macs are different: the file extension is not necessary for the software to recognize the file.

All image-editing applications have their own proprietary file formats, so it is not usually possible to open them in another program. However, generic formats such as JPEGs and TIFFs can be opened in different applications. JPEG (.jpg on the PC) is the most common format. This is the format that nearly all digital cameras use to store the photographs that you shoot. On some high-end cameras, there is an option to use RAW format. It is called RAW because the data that makes up the image is untouched by the camera's built-in processing software.

For the purposes of this book, however, we will assume that the photos in your digital camera are JPEG. With JPEG, the image data is 'compressed' so that more images can fit on the memory card. With highly compressed images, there is a trade-off with quality. Most digital cameras offer some control over the amount of compression. 'Good', 'Better' or 'Best' are typical options, with 'Good' being the smallest files and 'Best', the largest.

getting started

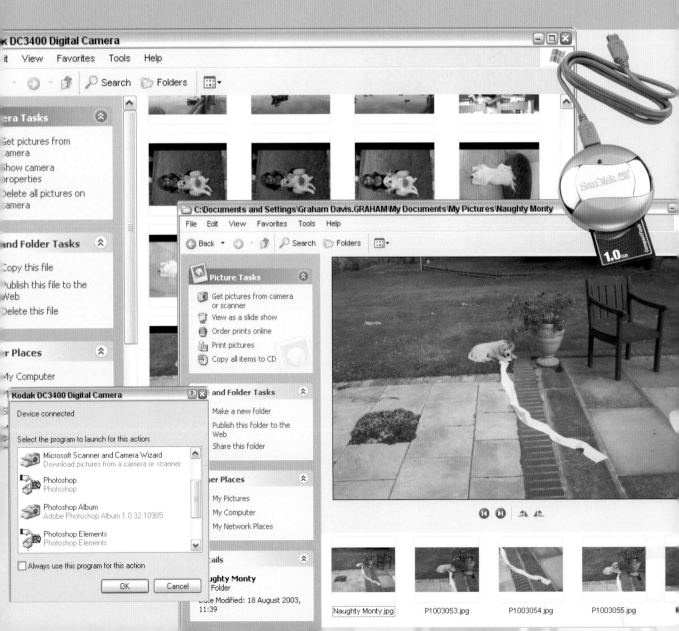

Before you can show off your digital photographs to family and friends, you first have to transfer your images from your camera or scanner into the computer. If you are working on a PC, your computer will have numerous 'wizards' (help boxes) to show you how to do this. Apple Macintosh computers also have a number of tip and hint boxes to make your life easier. And before your photo collection becomes too large, it is prudent to plan how you are going to organize it. Once you've got your files organized, it's sensible to archive them onto CD. Finally, to get perfect prints, you'll need to spend time setting up your printer correctly and using the appropriate paper. This chapter helps you to achieve all these things and more.

CHAPTER CONTENTS

getting an image from a digital camera

The first stage of accessing the photographs you've taken with your digital camera is to connect your camera to the computer. Once you've done that, you can start to copy your images across.

There are three ways to connect to your computer:

❶ connecting the camera direct to computer;

❷ inserting the memory card into a card reader, which is already connected to the computer;

❸ placing the camera into a docking station and connecting that to the computer.

To connect, plug one end of the cable into the camera, card reader or docking station USB port and the other end into the computer USB (for some models, Firewire may be an alternative to USB).

You will probably be prompted to install software that comes with the camera, card reader or docking station before you connect the cable. Once this is complete, an icon should appear on the desktop containing all the photos stored in the camera's memory card.

→ **tip**

Connect mode

With some models, the camera should not be left on *Picture Taking* or *Reviewing* mode, or it will not connect to the computer. If this is the case with your model, ensure that the camera is set to *Connect* mode. Not all cameras use the same terminology, but it should be obvious from the options on your cameras controls which this is.

CONNECTING VIA USB CABLE

The digital camera is connected to the computer using either a USB or Firewire port. The camera has to be turned on, so be aware that the battery will be running down while you are transferring your images to the computer.

CONNECTING VIA A CARD READER

This single-format card reader accepts a 1GB compact flash card with enough space for 3000 medium-resolution images.

Double-click the card reader icon on the desktop. This fires up a screen showing thumbnails of the images on the card. They can then be transferred in the way previously described. If you right-click a thumbnail photo in XP, you will be able to view a large preview image.

CONNECTING VIA A DOCKING STATION

The camera docking/transfer process will vary with manufacturer. The Kodak EasyShare range is typical. The camera is placed into the dock, which is connected by cable to the computer. Pushing the connect button will automatically transfer the images to the computer.

Docking stations (or cradles) allows you to transfer images directly to your computer while charging the camera's battery at the same time.

COPYING IMAGES TO YOUR COMPUTER

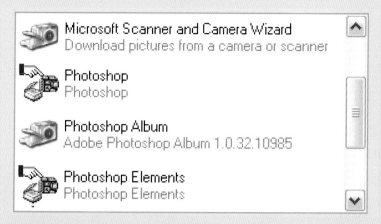

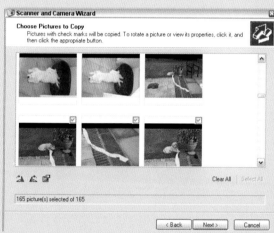

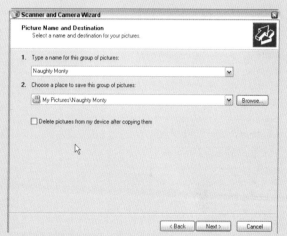

◀ On a Windows XP computer, connecting the camera by cable to the computer brings up the option *Select the program to launch this action*. This lists the applications that are able to import photos direct from the camera, among them the *Microsoft Scanner and Camera Wizard*.

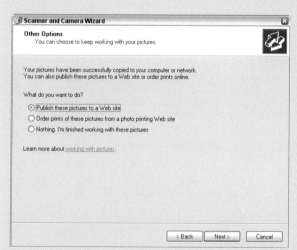

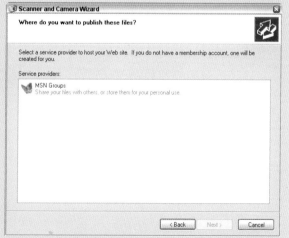

▲ After the welcome screen, you will be prompted both to select the photos that you want to transfer and to choose their location on your computer. At the end of the process, you have the option of publishing the images to a website if you have already registered with a suitable service, such as MSN Groups *(see pages 158–159)*.

getting technical

GO WIRELESS

Some computers and cameras feature technology that utilize radio waves to transfer information. If you use such a 'Wireless-enabled' computer and camera, it is possible to transfer photos without any physical connection between the two. The technology is similar to a mobile phone. Many notebook computers have WI-FI facility and desktop computers are catching up quickly. Before purchasing a digital camera, check that it is WI-FI enabled if you wish to transfer images this way.

TRANSFERRING USING AN APPLICATION

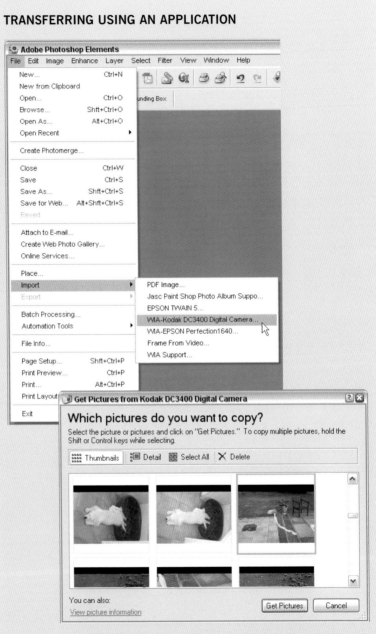

▲ You can also transfer images through applications such as Photoshop Elements. Once you have launched the application, select the camera using the *Import* option from the *File* menu. You will be prompted to select the photos that you wish to copy. These will then be opened in Photoshop Elements.

TRANSFERRING WITH THE CAMERA ICON

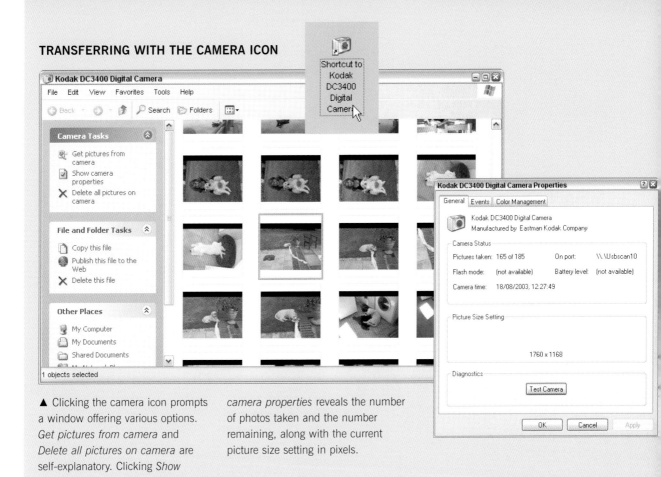

▲ Clicking the camera icon prompts a window offering various options. *Get pictures from camera* and *Delete all pictures on camera* are self-explanatory. Clicking *Show*

camera properties reveals the number of photos taken and the number remaining, along with the current picture size setting in pixels.

◄ The *View* menu gives you the option of seeing the images as a filmstrip. If you cannot see the filmstrip, right-click the folder to view its properties, select *What kind of folder do you want?* from the *Customize* tab and then make sure that either *Pictures* or *Photo Album* is selected.

scanning and transferring photos

To scan a photograph, you first need to install the scanner software and connect the scanner to either a **USB** or **Firewire** port. Scanner software comprises two parts: the first part may include options to print the scanned image directly, or to fax or email it. The second part (known as **TWAIN**) enables you to scan from within any application (such as Photoshop Elements) that supports **TWAIN**. For example, if you are using a word-processing package, you may want to scan in a document to be included in a report you are preparing.

HOW TO SCAN AN IMAGE USING PHOTOSHOP ELEMENTS

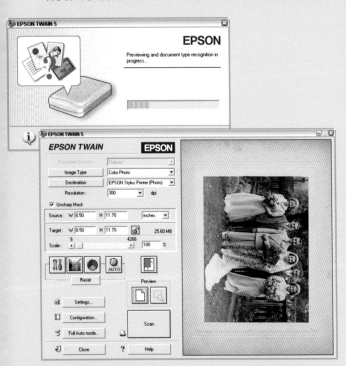

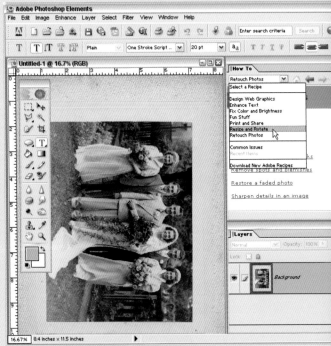

1 From the Photoshop Elements *File* menu, select *Import/TWAIN* option. A typical scanner has two options: full auto or manual scan. If the manual option (above) looks too intimidating, use the *auto* option.

2 Whichever method you use, the resulting scan will appear within Elements. You can then use options such as *Resize and Rotate* to alter, enhance and retouch the image.

TRANSFERRING USING THE *SCANNER AND CAMERA WIZARD*

Scanner and Camera Wizard

Picture Name and Destination
Select a name and destination for your pictures.

1. Type a name for this group of pictures:

 Family Weddings Kate

2. Select a file format:

 JPG (Generic JPEG)

3. Choose a place to save this group of pictures:

 My Pictures\Family Weddings Kate Browse...

Scanner and Camera Wizard

Scanning Picture
Please wait while the wizard scans your picture.

Location:
My Pictures\Family Weddings Kate

Picture:
Family Weddings Kate.jpg

Picture progress: 37% complete

1 Scanning an old black-and-white photo as a colour picture results in a richer image. Click the preview button to see the photo in its pre-scanned state.

2 If you click on *Next*, a window appears prompting a name and place to store your pictures. By default, this will be the *My Pictures* folder, although you can select an alternative location and folder if you wish. You will then have to select a file format (*see box below*) for the scanned photo. The default option is JPEG (.jpg). Clicking *Next* again starts the scanning process.

3 When the scan is finished, you can view the photo and rotate it if necessary. Here, *View as Filmstrip* has been selected from the *View* menu. This is useful if you have scanned a number of images and wish to select one to view at a larger scale.

jargon buster

- **PPI (pixels per inch)** describes the number of pixels displayed on your computer screen. When they appear on screen, digital images are defined in terms of PPI.

- **DPI (dots per inch)** are physical marks on paper or other media made as a result of printing by a laser or inkjet printer.

- **LPI (lines per inch)** is the term for resolution in commercial printing such as this book.

getting technical

Saving photos

If you scan an image using the *Scanner and Camera Wizard*, you will be asked to select a file format (*see pages 14–15*). The choices are all generic, e.g., .BMP, .JPG, .TIF and .PNG, and are used by most Windows applications. If you scan using TWAIN, the image will be saved in the application's own file format. Photoshop Elements uses the format .PSD. This format has various advantages. As a PSD-formatted file, an image can have a number of layers (*see pages 38–39*) so several images can be combined – essential for most of the projects shown in this book. The transparency (*Opacity*) of each layer can be varied, so that for example an image on a layer above can be translucent rather than opaque, partially revealing the image on the layer below. Once you are happy with the scan, save it. If you want to share the image, use *Save As* to save a copy of it in a generic format such as .JPG.

organizing image files and burning CDs/DVDs

Keeping track of the files on your computer has always been a problem, and when you start adding large numbers of photos from your digital camera, the problem is compounded – particularly when a typical file name is DCP_2646.JPG. Once you've organized your files, you'll need to copy them to CD to keep them safe.

The problem begins when the photo is taken. For example, on a typical holiday, is it possible to remember every place name where a photo was taken, or the names of people we met? Help is at hand in the form of a feature of the JPEG format that most digital cameras use. It is called EXIF (Exchangeable Image File Format). It includes technical data like exposure and shutter speed. What we are most interested in is date and time. This is recorded for every photo that you take. If you keep a notebook of the date and time you start shooting a new subject, it should not be too difficult to identify your photos later.

So, how do you organize your photos once they are on your computer?

In Windows XP, the folder *My Documents/My Pictures* will be selected as the storage place for your photos by default. You can, of course, choose a different location in which to save your images if you prefer. It is time-consuming to rename every file using a description rather than the numerical file name generated by the camera. A better option is to create folders with descriptive names and use the folder's thumbnail view to select the appropriate images to put in it. Avoid putting too many folders within folders.

Making CDs and DVDs

Both Windows XP and the Macintosh OS allow for drag-and-drop CD writing, with no additional software needed. CD writers are usually supplied with additional software that gives access to additional features. Either Nero Burning Rom or Easy CD Creator are supplied with most Windows XP machines. Toast is the preferred option on the Mac.

The importance of organizing your photographs becomes even more apparent when you make CDs or DVDs. It can be very irritating to look at a CD made six months earlier and find all the photos labelled only with numerical file names, giving you no means of finding a particular image.

→ tip

File info in elements

If you open a file in Elements and then select *File Info* from the *File* menu, clicking the *EXIF* tab will reveal a lot of information about that image, including the camera used and the time and date that the photo was taken. Under the *General* tabs, you can add additional information to the image, such as a caption.

Name	Size	Type	Date Created
P1003478.jpg	288 KB	Generic JPEG	18/10/2003 17:34
P1003479.jpg	160 KB	Generic JPEG	18/10/2003 17:34
P1003480.jpg	288 KB	Generic JPEG	18/10/2003 17:34
P1003481.jpg	224 KB	Generic JPEG	18/10/2003 17:35
P1003482.jpg	192 KB	Generic JPEG	18/10/2003 17:35
P1003483.jpg	224 KB	Generic JPEG	18/10/2003 17:36
P1003484.jpg	128 KB	Generic JPEG	18/10/2003 17:36
P1003485.jpg	320 KB	Generic JPEG	18/10/2003 17:36
P1003486.jpg	352 KB	Generic JPEG	18/10/2003 17:36
P1003487.jpg	352 KB	Generic JPEG	18/10/2003 17:37
P1003488.jpg	384 KB	Generic JPEG	18/10/2003 17:37
P1003489.jpg	320 KB	Generic JPEG	18/10/2003 17:38
P1003490.jpg	224 KB	Generic JPEG	18/10/2003 18:35
P1003491.jpg	384 KB	Generic JPEG	18/10/2003 18:36
P1003492.jpg	384 KB	Generic JPEG	18/10/2003 18:36
P1003493.jpg	320 KB	Generic JPEG	18/10/2003 18:36
P1003494.jpg	352 KB	Generic JPEG	18/10/2003 18:36
P1003495.jpg	320 KB	Generic JPEG	18/10/2003 18:37
P1003496.jpg	192 KB	Generic JPEG	18/10/2003 19:26
P1003497.jpg	224 KB	Generic JPEG	18/10/2003 19:27
P1003498.jpg	64 KB	Generic JPEG	18/10/2003 19:27
P1003499.jpg	256 KB	Generic JPEG	18/10/2003 19:27
P1003500.jpg	256 KB	Generic JPEG	18/10/2003 19:28
P1003501.jpg	352 KB	Generic JPEG	18/10/2003 19:28
P1003502.jpg	96 KB	Generic JPEG	18/10/2003 19:28
P1003503.jpg	160 KB	Generic JPEG	18/10/2003 19:28
P1003504.jpg	224 KB	Generic JPEG	18/10/2003 19:29
P1003505.jpg	288 KB	Generic JPEG	18/10/2003 19:29
P1003506.jpg	320 KB	Generic JPEG	18/10/2003 19:30
P1003507.jpg	352 KB	Generic JPEG	18/10/2003 19:30

Using simple notes like those taken at 'Gail's Graduation' allows you to organize photos on your computer. The shots taken between 16.57 and 17.00 are of the graduation ceremony, so files between these times can be put in a separate folder. Adding a numeral at the beginning of the folder name ensures that the folders appear in the correct sequence. Otherwise they default to alphabetical order.

NOTES

GAIL'S GRADUATION

DATE — TIME — DESCRIPTION
18·10·2003 16·57 Graduation
18·10·2003 17·01 Senate House
18·10·2003 17·54 Congratulations

My Pictures
- Gails Graduation
 - 1 The Graduation Ceremony
 - 2 The Senate House
 - 3 Congratulations
- Photos main

BURNING A CD

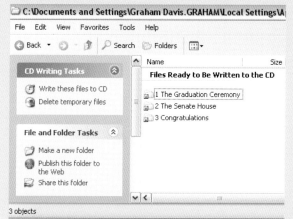

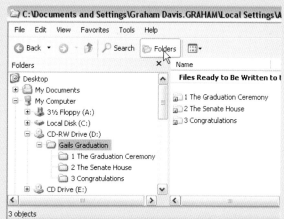

▲ Making a CD is very simple. With a blank CD in the CD writer, double-click the *CD-RW Drive* (see next dialog box) in *My Computer*. Drag the folders to be copied and drop them onto the blank window. Select *Write these files to CD* from the *CD Writing Tasks* panel, and the job is

done. If you change your mind, use *Delete temporary files* to remove them. You can toggle between *Task* and *Explore* mode by clicking the *Folders* button. The latter is useful if you are copying a lot of folders or if you are not sure in which folder the photos to be copied have been stored.

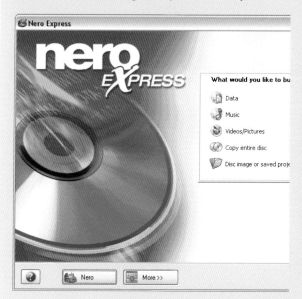

▲ If you plan to send your CD to a family member or friend and do not know what type of computer or operating system (OS) they use, it is generally safer to use an application like Nero Express. This has a wider range of format options than Window XP's own CD burner. You can even make a video CD that can be played on a TV-based DVD player.

▲ If you want to create a DVD rather than a CD, you will need a dedicated application like Adobe Encore. (If you're working on a Macintosh, you can use iDVD). The 4.7Gb capacity of a DVD makes them much more suited to recording video rather than still images.

image editing and printing

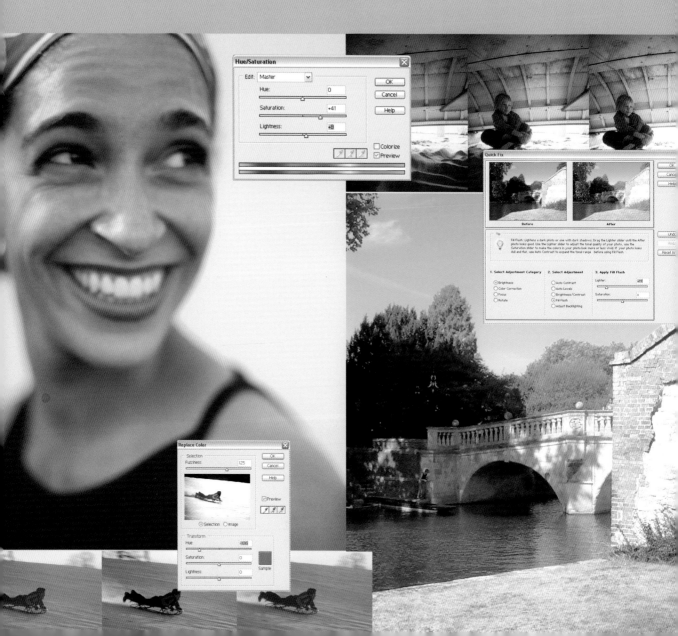

Although digital cameras generally take great pictures, there will inevitably be occasions when a photo needs some improvement. You turned off the red-eye option by mistake; your subject is in shadow; or your camera angle was skewed – these are all common enough mistakes. If you are scanning old colour photos, they may be faded or have an unwanted colour bias that you want to correct. In this chapter, our demonstrations use Adobe Photoshop Elements extensively, as this is the most popular image-editing software for amateur photographers. Your camera or scanner may have been supplied with similar software; fortunately, most have similar tools and interfaces.

CHAPTER CONTENTS

image-editing tools

Opening an image-editing application for the first time can seem daunting. Fortunately, Adobe Photoshop Elements has been devised with the amateur photographer and computer novice in mind. Over the next few pages, we explain how to use the basic image-editing tools.

The *Toolbox* is a good place to start. It contains the tools that you will use to select a particular area of an image in order to work on it; a simple rectangle, perhaps, or an irregular shape like the outline of a building. There are brushes and pencils to draw with and an eraser to remove anything that you no longer need. There are simple retouching tools to blur or sharpen and others to clone an area so that it can be applied elsewhere. This is very useful if you need to 'patch up' a damaged photo or you want to remove unwanted objects from an image, such as a garden tool from an otherwise pristine lawn. There is the *Eyedropper*, which allows you to sample any colour in an image. This is useful if, for example, you want to match a border colour to one in the image. There is a *Text* tool, a *Zoom* tool, and the *Foreground and Background colour selectors*. You will soon become familiar with the tools you use often.

For every tool, there is a *Hints* palette that helps you to complete a task, along with the *How To/Recipes* palette that actually does the job for you – for example, *Fix a torn photo*. In the *Palette Well,* the tabbed palettes offer more features and effects. The *Undo History* palette, for instance, shows your recently completed tasks. Each can be undone by moving the arrow to a previous stage.

The Toolbox holds 24 tools for creating and editing images. Some have flyout menus that offer variations of the basic tool. All tools have additional options, like size or colour. These are available from the Options Bar.

RECTANGULAR MARQUEE TOOL
Selects a rectangular area on your image so that you can work on that part of it (this is referred to as 'a selection') without affecting the rest of the image.
FLYOUT: **Elliptical Marquee**

MOVE TOOL
Allows you to drag a selected area to a new position.

LASSO TOOL
Draws a freehand selection around an image.
FLYOUT: **Polygonal and Magnetic Lasso tool.**

MAGIC WAND TOOL
Makes a selection based on common colours. Click on the blue in a sky, for example, and the clouds will be excluded from the selection. The Tolerance setting in the Options Bar *controls how far the selection extends into adjacent colours.*

SELECTION BRUSH TOOL
Enables an area of the image to be selected by painting it. Use this tool when a soft edge is required.

CROP TOOL
Makes a selection of a smaller area within an image and then crops the image to that area.

RECTANGLE TOOL
Draws a rectangle filled with the Foreground colour.
FLYOUT: **Rounded Rectangle, Ellipse, Polygon, Line, Custom Shape, Shape selection.**

HORIZONTAL TYPE TOOL
Enters normal horizontal type on a new layer. Set other font attributes with the Options Bar.
FLYOUT: **Vertical Type, Horizontal Type Mask, Vertical Type Mask.**

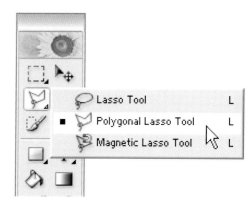

PAINT BUCKET TOOL
Fills a selection with a colour or pattern.

SMUDGE TOOL
Smudges colours as it is dragged across an image.

If there is a small arrow at the bottom right of the tool icon, holding the icon down brings up the flyout menu with variations of the tool.

GRADIENT TOOL
Fills a selection with graduated rather than flat colours. Select the style of gradient and the colours from the Options Bar.

DODGE TOOL
Lightens an area as it is dragged across an image.

When a tool is selected, its options automatically appear in the Options Bar. The Brush tool options comprise type and size along with a drop-down menu showing Presets, Mode and Opacity.

BRUSH TOOL
Paints brush strokes. Select brush styles and sizes from the Options Bar.
FLYOUT: **Impressionist.**

BURN TOOL
Darkens an area as it is dragged across an image.

PENCIL TOOL
Draws hard-edged lines. Select brush styles and sizes from the Options Bar.

CLONE STAMP TOOL
Copies an area of an image so that it can be 'dropped' in a new location. The size of the area to be cloned is determined by the brush or pen sizes, which are selected from the Options Bar.
FLYOUT: **Pattern Stamp tool.**

ERASER TOOL
Erases as it is dragged across an image.
FLYOUT: **Background Eraser, Magic Eraser.**

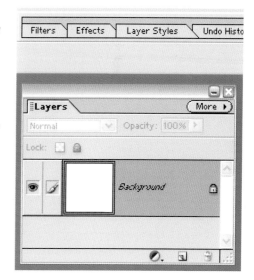

EYEDROPPER TOOL
Samples colours within an image. When clicked, the sample colour becomes the new foreground colour.

RED EYE BRUSH TOOL
Removes red-eye effect on photos taken with a flash.

HAND TOOL
Drag over an image to view areas not visible.

BLUR TOOL
Blurs hard edges as it is dragged across an image.

ZOOM TOOL
Zooms in or out of an image. The actual image size remains unchanged.

SHARPEN TOOL
Sharpens soft edges as it is dragged across an image.

FOREGROUND and BACKGROUND COLOUR SELECTORS
Selects the foreground or background colour.

The Palette Well contains tabbed palettes. These snap back automatically after use. If you want them to stay open permanently, they can be dragged out of the Well and moved elsewhere in the work area. Here, the Layers palette has been dragged out.

SPONGE TOOL
Changes the colour saturation as it is dragged across an image.

basic image-editing techniques

Before you can undertake any task in Elements (or in any other software), you have to make a selection. If you want to make a change, like rotate or flip, to the entire image, it can be selected from the *Image* drop-down menu. If you want to change just part of the image, you have to select that section. Once selected, that part of the image can be worked on without affecting the rest of the picture.

A photograph that has been transferred from your digital camera will be in the generic JPEG (.JPG) format (*see page 15*). When you open the photo in Elements, the image will appear as a locked Background. This means that you cannot edit it. Before you can apply a transformation, such as *Rotation*, you need to convert the background to an editable layer. You can duplicate the layer (*see pages 38–39*) if you prefer not to work on your original photograph.

If you resize a photograph, bear in mind that the quality is likely to suffer if you enlarge it more than about 10%. If you require larger images on a regular basis, it is better to increase the quality and resolution setting in your camera. Reducing the image size is not a problem.

→ tip

Duplicate Layer
Before making changes to an image, you can, of course, make a copy and work on that. If you want to be able to compare the original with the altered version, you can duplicate the layer (*see pages 38–39*). This makes it easier to compare the two versions. In the *Layers* palette, click on the original Layer, and drag and drop it over the *Create New Layer* icon. A duplicate will be created. When you save a layered file, it will be in Elements own .PSD file format, not a JPEG.

RESIZING

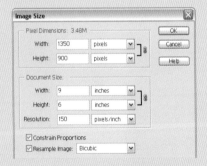

▲ Select *Resize/Image Size* from the *Image* drop-down menu. To change the image size, type in a new *Width* or *Height*. Keeping *Constrain Proportions* checked ensures the image retains the same proportions as before. *Resample Image* should be checked.

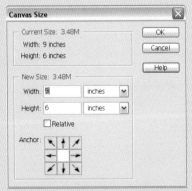

▲ If you want to create a border around the image, change *Canvas Size* rather than *Image Size*. If the *Anchor Point* is central, the additional space will be added equally on all sides.

▲ The *Image* drop-down menu contains a range of transformations that can be applied to the entire image.

CROPPING

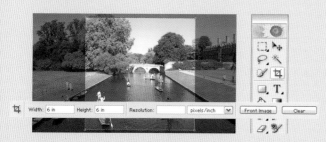

▲ You can set the crop size (here, 6 x 6in/15 x 15cm), in the *Options* menu, having first selected the *Crop* tool. Drag the marquee to the area required. The image will be cropped to this size. Use the right mouse button to cancel if required.

ROTATING

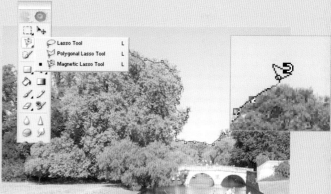

Resize

Rotate

▲ Use the *Elliptical Marquee* to draw a selection; holding the *Shift* key down constrains the shape to a circle. Click on the *Move* tool and handles appear around the selection. Drag one of the corner handles to rotate the selection to a new position.

MAKING SELECTIONS

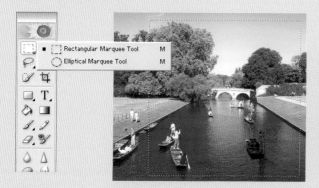

▲ Use one of the *Marquee* tools (here, the *Rectangular Marquee*) and press the *Shift* and *Alt* keys. Place the cursor in the middle of the image and drag it towards the edge. The selection will be centred around the original cursor position.

▲ The *Magnetic Lasso* tool is another useful selection tool. It gets its name from the fact that as you run the cursor along the object you're selecting the selection line 'sticks' to the object. It does this by differentiating between pixel colours.

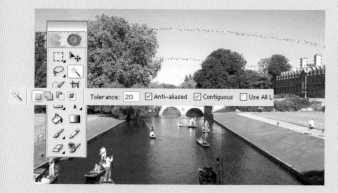

▲ Using the *Magic Wand* tool with the *Tolerance* set to 20 in the *Options* menu, click in the central sky area. The resulting selection will contain only a small area of sky.

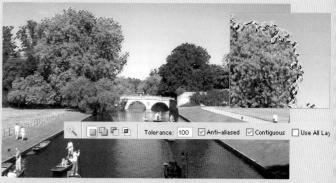

▲ If you increase the *Tolerance* setting to 100, all of the sky is selected. The enlarged details shows that some of the trees are also included in the selection. This method works best when there is a big colour difference between areas.

correcting exposure

Most digital cameras take good quality photos most of the time. However, if you leave your camera on fully automatic mode, or if your camera doesn't have any manual override, there will be times when the camera doesn't make the right decision.

This is particularly true of scenes that are partly in shadow. To retain detail within the shadow would mean lightening the rest of the image to an unacceptable degree, so the camera makes a compromise. Elements has a number of tools to overcome exposure problems. There will be occasions when you want to use these tools to create a special effect, like increasing contrast.

Sometimes you need to mask a photo to apply the improvement to a particular area. Use one of the selection methods described on pages 28-29 and always apply the correction to a duplicate of the original photo Layer.

As every image is different, Elements offers alternative methods of achieving a given result. With a little trial and error, most exposure problems can be overcome. As your confidence builds, you may find using more than one technique on a single image will yield the best results.

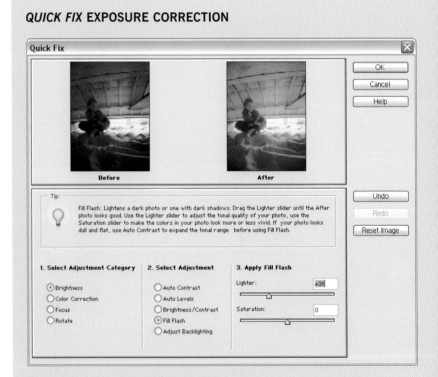

QUICK FIX **EXPOSURE CORRECTION**

▲ An alternative method of improving this photo is to use *Quick Fix* from the *Enhance* drop-down menu. With the *Fill Flash* option selected, drag the slider to +31. The shadow area is opened up considerably.

SELECTIVE EXPOSURE CORRECTION

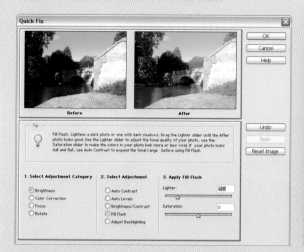

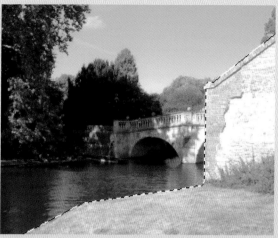

1 Applying an overall correction will not always work. Here there is a large shadow area in the background and a brightly lit wall in the foreground, which must be excluded from the lightening process. On a duplicate layer, use *Fill Flash*. Drag the Lighter slider to +19. This opens up the whole image.

2 Zoom the image to a convenient size. Using the *Polygonal Lasso* tool in series of tiny steps, trace round the foreground area. Make sure the end of the trace joins with beginning. Now delete this area to allow the original image to show through in this area. Use the Ctrl+X shortcut to delete.

3 The original photo and the original photo with *Fill Flash* applied overall.

4 The *Fill Flash* Layer with the foreground removed to allow the original photo to show through.

correcting colour

Digital cameras are very good at recording colour, so it is unlikely that your photos will need much improvement in this area. It is more likely that colour changes will be made for effect rather than correction. This is not the case with scanned colour photos, however, especially old ones where colours may have faded inconsistently.

QUICK FIX COLOUR CORRECTION

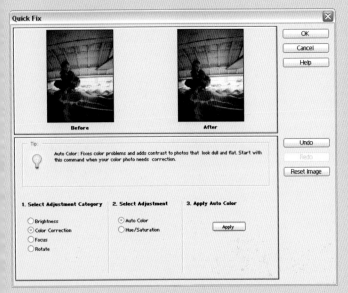

▲ The *Quick Fix* colour correction method works in the same way as using *Quick Fix* to adjust exposure (*see page 32*). Select *Quick Fix* from the *Enhance* drop-down menu and then click on the *Color Correction* button. You'll be given two options. One is *Auto Color*, which, if selected, assesses the image and makes what the computer thinks are the appropriate changes. The other is *Hue/Saturation*, which allows you to manually alter the hue, saturation and lightness of the image. In both cases, the *After* image previews the effect of the correction on your original image. As soon as you are happy with the correction, click *OK*.

ENHANCE FIX COLOUR CORRECTION

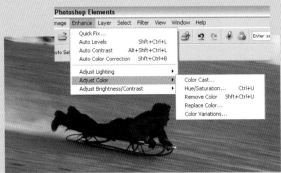

▲ There are five methods of colour correction available from the *Enhance* drop-down menu: *Quick Fix > Color Correction*; *Auto Color Correction*; *Adjust Color > Color Cast*; *> Hue and Saturation*; and *> Replace Color*. The colour in this shot is quite attractive but does look false.

▲ Click *Auto Color Correction*, and Elements will fix the colour for you. The snow is now bluer and more natural looking, but the picture looks a little dirty.

SELECTIVE COLOUR CORRECTION

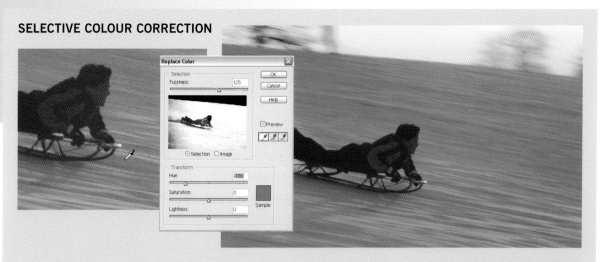

▲ The two previous methods apply an overall colour change. *Replace Color* allows you more discrimination. This method also uses the *Eyedropper* tool to sample a colour to be replaced. This time, the area just in front of the tobogganer is selected as representative of the general snow colour. The *Hue* slider is dragged to the left until the Sample shows it as blue. The *Fuzziness* slider controls the area of the image to which the new colour will be applied. The result is a bluer snow, but with some warm sunny highlights.

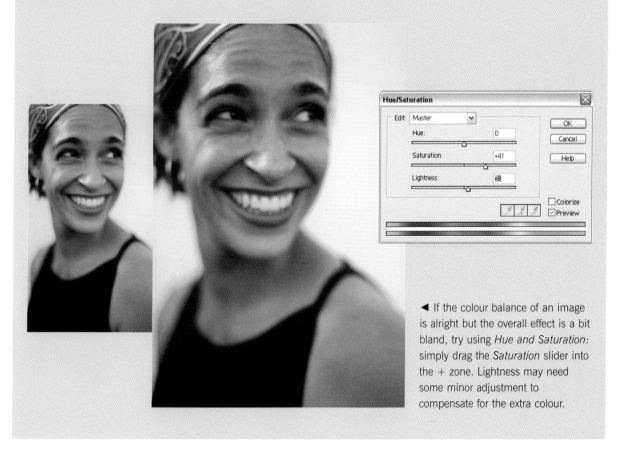

◄ If the colour balance of an image is alright but the overall effect is a bit bland, try using *Hue and Saturation*: simply drag the *Saturation* slider into the + zone. Lightness may need some minor adjustment to compensate for the extra colour.

sharpening images and fixing red-eye

You may find that the photos you take with your digital camera look a little 'soft' – not out of focus but just a bit blurred. Photoshop Elements has an excellent tool that helps you to 'sharpen' your images. Another problem is red-eye. Red-eye occurs when the red blood vessels in a subject's eyes have been lit by the camera's flash. We can fix that too.

Even the most experienced photographers sometimes find that an image looks a little soft, or fuzzy. There are several reasons for not having razor-sharp images every time. For example, the photo may have been taken in poor light or the camera's autofocus didn't deliver the intended effect. A scanned colour print is another likely candidate for a soft image.

Fortunately, most image-editing applications have a function that enables you to bring a soft image into sharper focus. The box on the right shows how you can sharpen an image using Elements' *Unsharp Mask*; other applications have similiar features. Creating an 'unsharp mask' is the process of hiding, or masking, the parts of the image that are unsharp.

Red-Eye

Most cameras have a red-eye option. This involves two flashes: the first makes the subject's pupils contract; the second is the actual exposure. Alternatively, most image-editing applications have options for removing red-eye, and Photoshop Elements' approach, shown on page 37, is typical.

SHARPENING USING UNSHARP MASK

▶ Select *Unsharp Mask* from the *Filters* menu. Drag the *Amount* slider up to 400% and the other two sliders to the left. Gradually drag the *Radius* slider to the right until the sharpening effect is visible. Then fine-tune the effect using the *Threshold* slider. Reduce the *Amount* percentage if the result is too extreme.

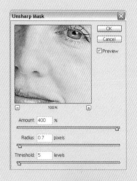

The before and after effect.

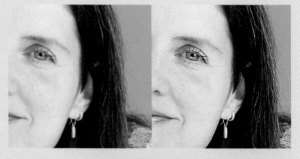

▶ Ensure that the image and the thumbnail in the *Unsharp Mask* dialog box are both set to 100% before sharpening, and click the preview on and off to see the effect on the original image. Sharpening affects the entire image, so use it with care.

FIXING RED-EYE

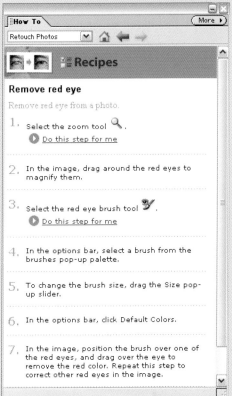

▲ This shot was taken without red-eye having first been selected from the camera menu. The result is two very red eyes.

The *Recipe* palette has a *Remove red eye* option that partly automates the process. The first step is to zoom in to the eye area.

◄ ▲ Next, select the *Red Eye Brush* tool from the *Tools* palette. Change the brush size so that it is just larger than the red eye area. Ensure that it is a round brush from the *Default Brushes*. Click the *Default Colors* button, but leave the other options unchanged.

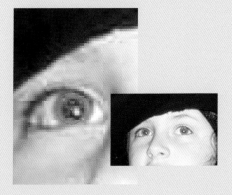

◄ With the *Red Eye Brush,* click on the offending areas until they have been removed. If the brush is too big or you stray beyond the red eyes, you will notice that these areas turn grey, as the *Red Eye* tool takes away colour, or 'desaturates', anything that it comes into contact with.

using layers

Layers are an essential part of any image-editing program. They allow you to place images on top of one another, while also controlling how transparent the layers are. For example, using layers enables you to put a photograph on top of a background image, and then a border on top of that.

CREATING AND USING LAYERS

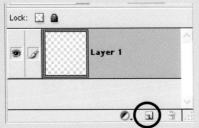

1 When you open a new document, you'll notice that there are no layers, just a *Background* layer that cannot be moved from the bottom of the stacking order when layers are added.

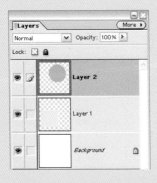

2 To create a new layer, click on the *Create a new layer* icon at the bottom of the *Layers* palette (in the circle shown above).

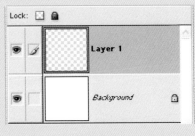

3 Alternatively, select the *Background* or any existing layer and then paste in an image, and a new layer will be created automatically.

4 On a new layer, draw a square using the *Rectangular Marquee* tool and fill it with yellow using the *Paint Bucket* tool.

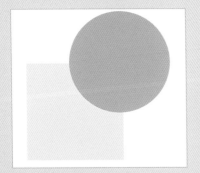

5 Use the *Elliptical Marquee* to make a blue circle on another new layer. In the *Layers* palette, you'll see the square on *Layer 1* and the circle on *Layer 2*.

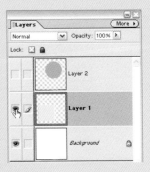

6 To turn a layer off (make it invisible), click on the eye icon in the left-hand column and it will disappear from your screen.

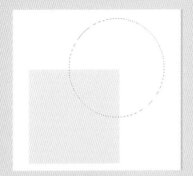

7 The selection of an image on one layer can be used to alter the image on a different layer.

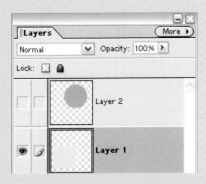

8 Using the *Magic Wand* tool, click on the blue circle to select it. Turn off *Layer 2* and select *Layer 1*.

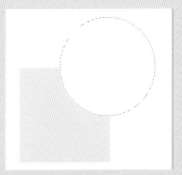

9 Hit the delete (backspace) key, and a circular portion of the yellow square is removed.

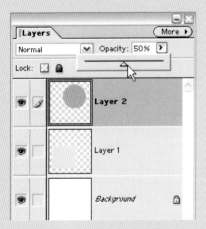

10 A layer is made semi-transparent by altering the *Opacity* slider. The effect applies to all layers beneath it.

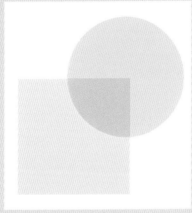

11 The layer *Blending Mode* is *Normal* by default. Other options alter the way layers interact with each other.

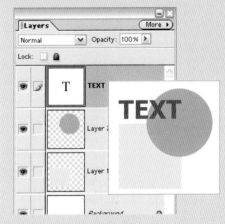

12 A text layer behaves like other layers, but the image thumbnail is replaced with a 'T' icon.

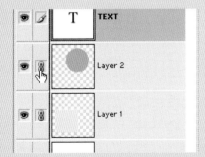

13 Clicking the Link icon links other layers to the one selected, allowing all to be moved together.

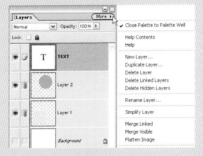

14 The *More* button reveals other options. *Simplify* is used to change a text layer into a graphic. It will no longer be editable, but additional effects can be applied to it.

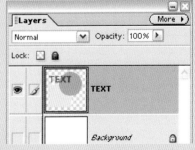

15 *Merge Visible* will condense all visible layers into one new layer that assumes the identity of the topmost layer. Ensure that the *Background* is not visible when you do this.

getting perfect prints

Printers, like scanners, are supplied with their own software, each featuring preferences that allow you to select print size and shape, resolution and paper type. To obtain the best-quality printing, it is necessary to understand at least some of them.

Each time you print from an application, you are able to select options such as paper size and quality. You can also change the default settings so that the options selected always appear as your first choice. In Windows XP, these options can be found in the *Printer Properties*. For Mac OS X, the printing options have to be set for each application individually.

To get the best quality from an inkjet printer, it is essential to select from the *Media* menu the paper type that matches the paper in your printer. The *Quality* settings usually control the resolution, typically ranging from 360 to 1440dpi. There is little point in using the *Draft Quality* setting (360dpi) on expensive Photo Quality Glossy paper. Conversely, do not try to print *Best Quality* on cheap copier paper.

Most printer manufacturers sell their own range of papers. They are often more expensive than generic ranges of paper, but the print quality is guaranteed. Compatible ink cartridges rather than branded ones are also available. Although the quality is often very good, some features may be missing. Don't be surprised if, for example, the ink usage indicator disappears when a cheaper (non-branded) cartridge is used.

A typical Mac OS X Print dialog. The main options are found in the Print Settings *drop-down menu.*

A typical Windows XP Printer Properties dialog. The only tab that needs configuring is Printing Preferences, *where you can change the print quality and paper quality and size. Most other options will have been configured during the printer installation and will not need to be changed.*

MATCHING PRINTER AND PAPER

The *Printing Preferences* have to be reset each time a different paper size or print quality is required. Here, a 4 x 6in (10cm x 15cm) Perforated Photo Paper has been selected (rather than the default A4 size).

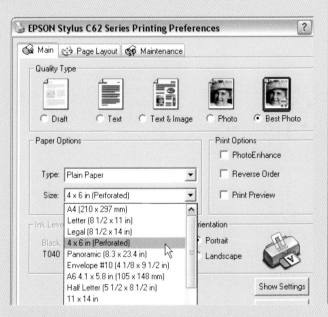

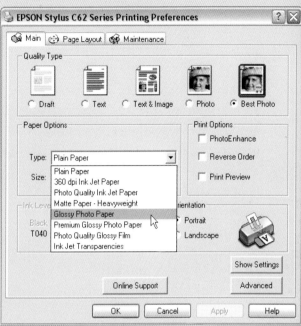

▲ Put the new paper in the printer paper tray and adjust the guides to fit. Select *4 x 6in Perforated* from the *Paper Options* drop-down menu. Check that the *Orientation* is correct – either *Portrait* or *Landscape*.

▲ Select *Glossy Photo Paper* from the *Paper Options* drop-down menu and select *Best Photo* from *Quality Type*.

APPLICATION-SPECIFIC PRINT OPTIONS

In addition to the options provided by the printer's software, some applications provide other features to make printing easier.

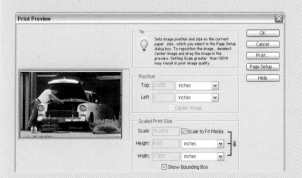

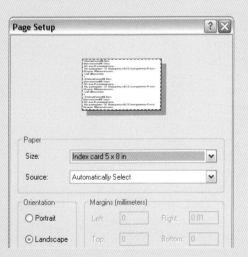

▲ *Print Preview* in Photoshop Elements displays the image to be printed. It has a *Scale to fit Media* option that reduces the image to fit the paper size.

▲ Paper size and orientation can be changed using the *Page Setup* button. If you want to access the full range of printer settings, hit the *Printer* button.

printing at the right resolution

Modern desktop printers offer fantastic quality, yet people are often disappointed with the results. The maxim 'you get out only what you put in' certainly applies to printing. Assuming that your printer preferences are correctly set up to match the paper quality that you are using (*see pages 40–41*), the problem is likely to be with the image that you are printing. One of the most common problems originates with your camera settings. To get as many photos on a disk as possible, your digital camera may be set up with the lowest-quality settings selected. This means that the resolution of the images will be low and that they are highly compressed to make the file sizes smaller and take up less memory.

Unless you are using a professional camera, your photos will be saved in .JPG (JPEG) format (*see page 15*). When a JPEG image is compressed, some of the image content is lost. This is sometimes referred to as a 'lossy' process. There are some lossless formats, like TIFF, but these allow for only a modest amount of compression. You may not realize that you are using a sub-standard image, as it may look all right on screen. If you are unsure, zoom the image to 100% in Elements or any other imaging application. If you see obvious pixelation – that is, blockiness or jaggedy edges rather then smooth tones – you may have a problem.

The problem is compounded when a poor-quality image is rescaled. Ideally, no photographic image should be enlarged. However, a good-quality uncompressed image can usually stand some degree of enlargement. Up to 25% is reasonable for output on a desktop printer. The higher the resolution of the printer, the more obvious any deficiencies in the original picture will appear.

If you are uncertain about your camera's quality set up, open a new A4 document in Elements with the resolution set to 200ppi and paste in an image from your camera. If it fills the entire area or beyond, you are probably all right, if the image is much smaller, you should try changing your camera settings.

Most of the projects in this book have been set up with a resolution set to 200ppi. Many experts will tell you this should be 300ppi. This is correct if you are a professional and your images will be printed using high-end commercial printing systems – 300ppi files are much larger, will take up more disk space and may slow your system down if you don't have a fast processor and lots of memory. For desktop printing, 200ppi should suffice.

getting technical

Building blocks

The problems discussed on this page occur because all digital images are made from tiny square blocks called pixels. In this detail, there are about 4900 pixels (70 across x 70 down). Each one has recorded a fragment of colour information. It is easy to see how an image can become pixelated when enlarged. Add to this the problems arising from compression. What JPEG does is to look at the image and decide that a particular group of pixels are so close in colour that no one will notice if they all become the same colour. Use the lowest resolution setting on your camera only if you know that images will only be viewed onscreen; otherwise use the fine or medium settings.

PIXELS PER INCH AND QUALITY SETTINGS

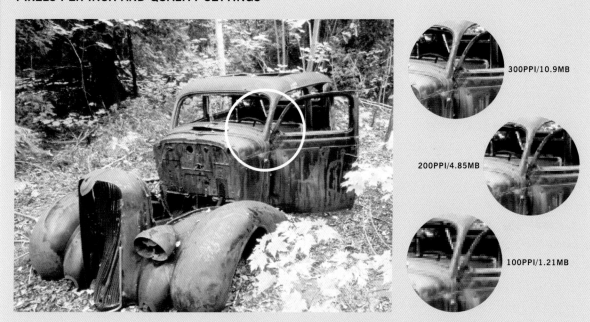

300PPI/10.9MB

200PPI/4.85MB

100PPI/1.21MB

▲ The three examples to the right of the main image demonstrate how print resolution, image size and file size are connected. Running top to bottom, we see how a 300ppi (pixels per inch) image, then a 200ppi image, and finally a 100ppi image will appear when printed at the same size. As the higher-resolution image (300ppi) has more pixels to every inch, it offers much better image quality, as more pixels are used to define the same area.

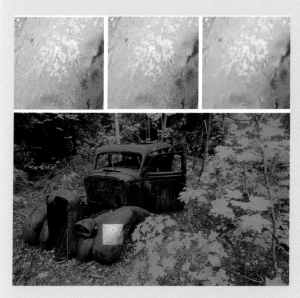

▲ The three enlarged details from the car wing have been saved in JPEG format at Maximum, Medium, and Low quality. The degradation of image quality is quite small for Medium quality but very marked at Low quality.

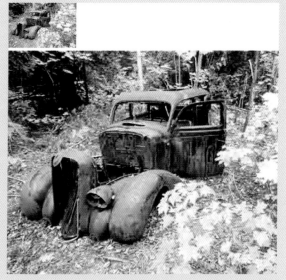

▲ This JPEG image saved at Low quality looks all right when small, but when enlarged about five times looks very poor.

ImageStation.

Get yours here.

CART HELP SIGN IN

SEARCH

Albums

Sony Store

Picture Gifts

Photo Books

Photo Book - Laminated Portrait

AlbumPrint Photo Book - Laminated Portrait

Already working on a project?

home printing vs. print shop

Anyone using this book to create projects is likely to have a desktop colour printer that prints high-quality images at a reasonable price. So why even consider using a professional printing service? Well, perhaps you want a poster-sized print for a celebration or some personalized coffee mugs to be used as gifts. Maybe you want the images laminated or professionally mounted, so why not let the supplier print them out as well? The Special Print Projects section (*see pages 92–107*) looks at these options in greater detail.

know your equipment

PAPER TYPES

In addition to branded printer manufacture papers, there is a wide variety of generic and specialist papers available. An idea of the range and variety is provided below. Always check with your supplier if the paper is compatible with your particular printer – not just the make, but the model too.

audio cassette J-card inserts backlit film for inkjet printers banner paper for inkjet printers • bookmarks brochure paper • tri-folds and card stock • bumper stickers & stickers • business cards • canvas paper for inkjet printers • CD stomper labels • decal paper embossing card stock for inkjet printers • fuzzy paper velour for inkjet printers glow-in-the-dark inkjet paper • greeting card envelopes greeting cards • index cards Iron-on transfers for fabrics and T-shirts • jigsaw puzzles for inkjet printers • key tags

address labels & shipping labels for inkjet printers circular labels for inkjet printers • VHS face and spine labels for inkjet printers magnetic sheets for inkjet printers • matte inkjet paper coated, on one or both sides metallic inkjet paper overhead transparency film painter's canvas • pearl essence art paper • photo quality, water resistant, inkjet photo paper & card stock • photo quality, inkjet paper • glossy photo quality • photo base, high gloss, inkjet paper • photo quality premium grade, glossy inkjet

paper • photo quality, professional grade, high gloss, water resistant, inkjet photo paper place cards for inkjet printers • postcards for inkjet printers • return address labels • shrink art for colour inkjet printers • t-shirt transfers – Kodak inkjet photo transfers • table talkers • table tent card stock tattoos • vellum envelopes vellum paper • window decals

The two areas in which your desktop printer may be deficient is print size and paper weight (thickness). The standard paper size for most printers, whether inkjet or laser, is A4, but many models will print A3 format and some have a roll feed attachment that enables banner printing. In part, the paper weight problem relates to the fact that most desktop printers are compact and a stiff sheet of card is not supple enough to bend its way round the rollers.

Many established names offer online printing services and most offer online sharing (*see page 122*). You can upload your images via the Internet, display them on free webpages, and use those same images to print from – the supplier will mail them to your home. The downside is that these services supply straightforward prints much as old-fashioned film processing services do, rather than the sort of projects included in this book.

Some supermarkets and malls offer printing and even scanning facilities. Some will burn a CD of your scans for you too. This is an option if you don't own a scanner. You will be limited to scanning two-dimensional images, unlike the buttons project on page 49.

Despite these developments, it is likely that most of your printing will be done at home. As well as standalone printers, multi-function devices are now very popular. These combine scanner, printer, copier and sometimes fax and email as well for little more than the cost of a mid-range printer.

MSN PHOTOS

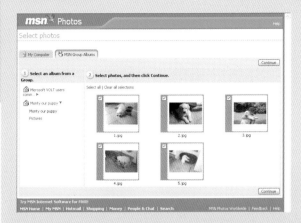

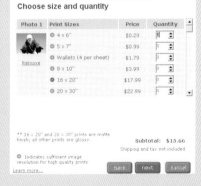

▲ Microsoft has a well established online printing service. It can be used in combination with MSN Groups that enable online sharing of photos.

Once you have joined or started your own group (online community) and uploaded your photos, you can have them printed and mailed to you at any time.

KODAK PRINT SERVICE

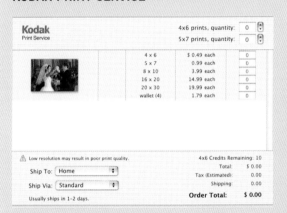

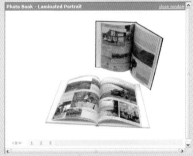

▲ Kodak has similar services: one for Windows XP users, called Ofoto; and one for Mac OS X users, accessed from iPhoto.

IMAGESTATION

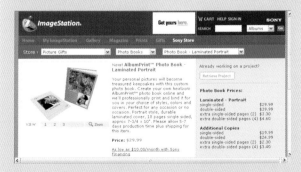

▲ Sony's ImageStation has gone one better. As well as providing a service comparable to MSN and Kodak's,

ImageStation also offers a service to create a bound book with your photos printed inside.

print projects

Please come
to Jo's 5th
Birthday

...and we
face-pair
look like
favorite
animal!

RSVP
9407 Sw Sample St.

Layer Styles More ▶

Drop Shadows

High Low Noisy

Hard Edge Soft Edge Outline

Fill/Outline Neon

April 2006

S	M	T	W	T	F	S
						1
2	3	4	5	6	7	8
9	10	11	12	13	14	15
16	17	18	19	20	21	22
23	24	25	26	27	28	29
30						

New

Name: Untitled-2 OK

Image Size: 3.6M Cancel

Preset Sizes: Custom

Width: 7 inches
Height: 4.5 inches
Resolution: 200 pixels/inch
Mode: RGB Color

Contents
○ White
○ Background Color
⊙ Transparent

On the trail to Cooper's Falls

Trekking with the Travis family
From Hayward Bridge to Cooper's Falls
16 May 2005
The Team:
Mom and Dad, Gramp's, Rachel, Gina
and Peter Travis (that's me)

8.40
Mom doesn't seem too sure of
Dad's map reading skills

11.50
No stoping these
young-uns

12.10
Gramp's feet are sore but
he doesn't seem to mind

1.25
Coop

9.10
Pure water, but how do you get it?

12.25
Just checking my GPS,
what do you mean it looks
like a Gameboy?

8.00
Setting off

10.10
We reach the "Silent Pool" just
10 minutes behind schedule.

10.45
Someone has to check
out the stones!

1.10
Wow! Do you think
avalanche damage?

The projects in this chapter can be created using most digital-imaging applications, although we have used Adobe Photoshop Elements. Follow the step-by-step instructions, and you will be surprised how easy it is to achieve professional-looking results. Most of these projects have been designed to be printed on A4 printers, the one you're most likely to have at home, but one or two projects have been set up to be printed on A3-sized paper. Although they will work on A4, we recommend you go to your nearest high-street developer or print shop with the file on a disk and ask for an A3 print – you'll be pleased with how great your work can look at twice the size you're used to seeing it at.

CHAPTER CONTENTS

1
borders and backgrounds

There are many ways of adding borders and backgrounds to your projects. One of them is to use traditional craft methods. Alternatively, borders can be scanned in as complete images and combined with your photos in an application such as Photoshop Elements.

Another method of creating an attractive border or background is to use small, individual objects such as buttons, postage stamps or pressed flowers (see pages 49–51). These items can be scanned in and combined with your photos using the computer to create an attractive image. You also have the option of creating borders and frames using Photoshop Elements. You can use the program's presets to fill an area with a pattern or texture, or you can use the *Clone Stamp* tool (see page 50) to create a less-regular effect.

If you plan to frame the completed project, it is sensible to buy or make the frame first so you know what size to make the border, background and photo. In that way, all the components will fit together neatly.

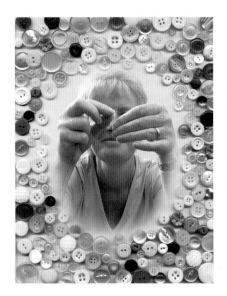

know your equipment

SCANNER SETTINGS

Each scanner uses slightly different software, so the interface of your scanner may not look the same as the one shown in Step 1. Don't be alarmed; the majority of settings can be left as default. Resolution is the crucial setting. For most tasks, 150dpi is sufficient. If you are scanning a small item, a higher resolution may be required (see pages 22–23 and page 43).

SCANNING REAL BUTTONS

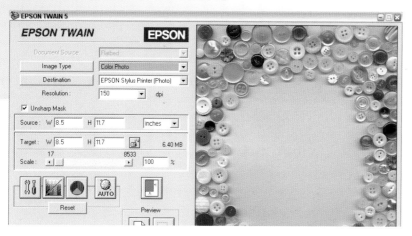

Before you arrange the buttons on the scanner glass, make sure that they are arranged to fit your finished piece. Here we are using measurements of 8.5 x 11in (21.5 x 28cm), which leaves a small margin at the bottom. (Scanners are designed to accept both a US letter-size document as well as European A4) Do not close the scanner lid. Instead, place a sheet of white paper over the top; otherwise the background will be black. Scan using default settings, but set the dpi to 150 and select colour. Save the scanned image and open it in Elements.

Although placing white paper over the buttons stops the background from going black, it does not produce a clean white background. To achieve this, duplicate the layer by dragging it onto the *Create New Layer* icon at the bottom of the menu.

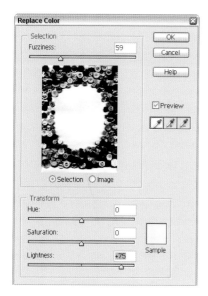

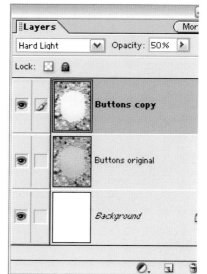

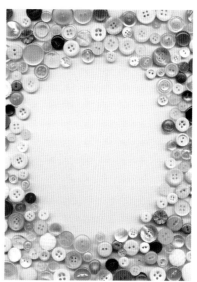

From the *Enhance* menu, select *Adjust Color>Replace Color*. Select the *Eyedropper* tool and sample the off-white colour at the centre of the image. Set *Fuzziness* to 59 and *Lightness* to +75. This lightens the image, especially the background.

The buttons on the layer we have just created are a bit too light, so reduce *Opacity* to 50% and change the *Layer Blending* mode to *Hard Light*. This allows some of the original layer to show through and puts the richness of colour back into the buttons.

The final border image is now ready to receive a photo.

SCANNING A SMALL FLOWER

1 Choose a flower to scan. We've used a small pink flower and scanned it at 400dpi, as it is only 1 inch (2.5cm) wide. This time, do not cover it with white paper, as the black background can be used to help 'cut out' the flower. Once scanned, open the image in Elements. Select the *Magic Wand* tool from the *Tools* menu and click it in the black area. A selection will then appear around the edge of the flower (a dotted line). Adjust the *Tolerance* in the *Options* menu until the selection fits tight to the flower.

2 Inverse the selection so it selects the flower rather than the background. Then select *Copy* from the *Edit* menu. Open a new document (here we have chosen 8.5 x 11in/21.5 x 28cm again) and paste the flower into it.

3 Drag the flower image to the top left of the page and reduce the size a little (if you wish) by clicking on one of the bounding box corners and dragging it towards the centre. From the *Tools* menu, select the *Clone Stamp* tool. From the *Options* menu, select a *Hard Round* brush and adjust the size so that it is a little bigger than the flower.

4 Place the cursor (which will now be the size of the brush that you specified) over the flower. With the *Alt* key pressed, click once. This loads the cursor with the cloned image. Move to an area where you want to place another flower and click again. This copies the cloned image in that place. Repeat this until you have covered the area that you require.

5 Create a new layer and paste in the flower image again, but this time make it larger, and reduce the layer *Opacity* to 28%. Repeat the process of Clone Stamping, but don't forget to enlarge the brush size.

PHOTOSHOP ELEMENTS PATTERN FILL

1 Elements allows you to fill areas with patterns. There are plenty of presets, but creating a custom pattern is easy. We've used a motif scanned from a Christmas card, but you could use one of your own images. Create a new document with a transparent background at 1.7 x 1.7in (4.3 x 4.3cm) so the pattern will repeat five times and fill the width of the page (5 x 4.3 = 21.5cm). Paste two copies of the image, one top left, the other bottom right, to give a wallpaper effect when the pattern is applied.

2 From the *Edit* menu, select *Define Pattern* and give it a name when prompted. This pattern is now stored for you to use in future projects. Once that's done, open a new page (21.5 x 28cm again) and create a new layer. Select the *Paint Bucket* tool from the *Tools* menu, and select *Pattern* from the *Options Bar*. The new pattern will appear at the bottom of the drop-down menu. Next, use the *Paint Bucket* tool to fill the newly created layer with your pattern.

3 Add a new layer below the pattern layer. Using the *Paint Bucket* tool, fill it with a colour of your choice. Reset the *Fill* options on the *Options Bar* to *Foreground,* or the area will fill with the pattern again.

4 To convert the overall background to a border, simply add a new Layer above the others. Using the *Rectangular Marquee* tool from the *Tools* menu, define an area and then fill it with white.

5 In order to give the border some depth, go to the *Bevels* menu in the *Layer Styles* palette, then select *Simple Sharp Pillow Emboss.*

a greeting card

This project was inspired by a snapshot of the photographer's daughter after a sleepover with friends. The addition of her favourite teddy bear required an extra photo, which was shot (without flash) on a summer afternoon. The text adds to the charm of the shot, as it appears to be spoken by the bear rather than the child.

If you plan to mail your greeting card, you will have to work back from the envelope size that you plan to use. For this project, we have chosen a $4^{1}/_{3}$ x $5^{3}/_{4}$in (11cm x 14.5cm). The greeting card is a standard inkjet card size of 8 x 5in (20 x 13cm), folding once to become 4 x 5in (10 x 13cm). The ideal size to fit the envelope is a fraction larger, at $8^{1}/_{2}$ x $5^{1}/_{2}$in (21.5 x 14cm) folding once to become $4^{1}/_{4}$ x $5^{1}/_{2}$in (10.75 x 14cm). However, this is not an inkjet card size. You can, of course, print on a larger sized card and trim it down afterwards if you wish. When matching standard printer paper sizes to an envelope, try cutting a piece of folded scrap paper to the paper size before starting the project, to check whether it will fit the envelope comfortably.

The outside of the card will be printed with the front image on the right-hand side so that it is in the correct position when folded; the same applies to the message on the reverse side. Unless your printer has a duplex printing facility (allowing it to print on both sides of the paper at once), you will have to print the two faces of the card separately. When printing the reverse side, take care to insert the card into the printer with the correct orientation. The card's thickness is defined by weight. A typical weight of card will be 185gsm. Not all cards and papers are suitable for double-sided printing, so check this with your supplier before you start.

The finished thank you card ready to send out to your friends and their bears.

TEDDY BEAR GREETING CARD

In this example, we'll be showing you how to combine two photos together to make a greetings card, and how to add your own text – and text effects – to the card.

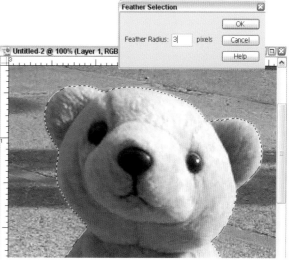

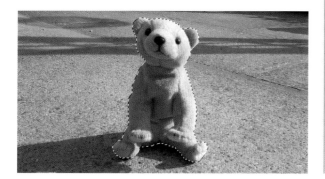

The shot of the teddy bear was taken against a plain background so the image could be easily cut out. From the *Tools* menu, pick the *Magnetic Lasso* tool and trace around the bear. Use the *Edge Contrast* setting in the *Options Bar* to better control the selection. The lower the contrast between the object and the background, the lower this setting should be.

Once you've completed the selection, choose the *Feather* option from the *Select* menu and set the *Feather Radius* to about 3 pixels. This will create a softer edge when the image is cut out. Setting this can be a case of trial and error. As a rule, the higher the image resolution, the greater the radius will have to be to obtain the same effect.

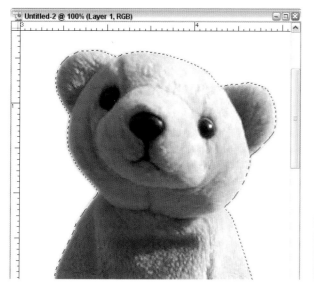

From the *Select* menu, choose *Inverse* and then use *Edit > Cut* to remove the background, leaving only the bear. The image is now ready to be added to the card.

The photo is smaller than the size of our greetings card, so create a new document for your card at 8 x 5in (20 x 13cm) with a resolution between 150 and 300ppi. Create a new layer (Layer 1) and use the *Fill* tool to fill it with black. Then change the layer *Opacity* to about 65%.

5 Create another new layer (Layer 2). Using the *Rectangular Marquee* tool, define an area on the right half of the page that leaves about å $1/4$-in (0.6-cm) margin round what will be the front face of the card. Fill this area with black again and this time change the *Opacity* to 25%.

6 Return to the bear document. Choose *All* from the *Select* menu and then *Copy* from the *Edit* menu. Next, return again to the card document and paste the bear image above the other layers.

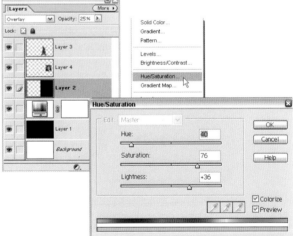

7 Open the image of the child. Using the *Rectangular Marquee* tool from the *Tools* menu, select the area of the image that you wish to use and then select *Copy* from the *Edit* menu. Return again to the card document and paste the image immediately below the layer containing the bear.

8 Select the layer created in step 4 (Layer 1), and create a new adjustment layer by clicking the icon at the base of the *Layers* palette. Then select *Hue/Saturation*. Check the *Colorize* button and adjust the three sliders (*Hue*, *Saturation* and *Brightness*) to create your desired colour. The adjustment layer allows you to experiment with colours without affecting the original image. Select the layer created in step 5 (Layer 2) and change the *Layer Blending Mode* to *Overlay*. This allows more of the orange to come through.

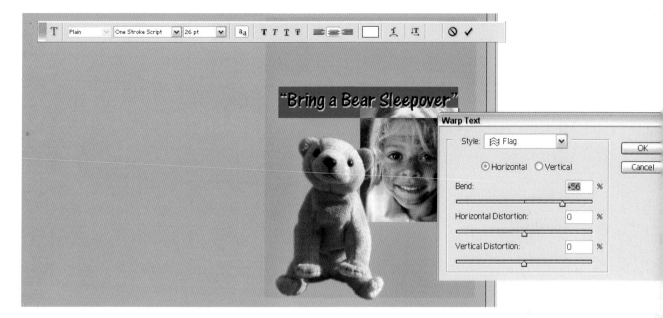

9 Now you can add the 'Bring a bear sleepover' text. Select the *Horizontal Type* tool from the *Tools* palette, create a new layer, and type in the text. The font will depend on those available on your computer. Select *Create Warped Text* from the *Options Bar* and choose the *Flag* style. Create the remaining paragraphs of text in the same way, but on two additional layers and without warping the text.

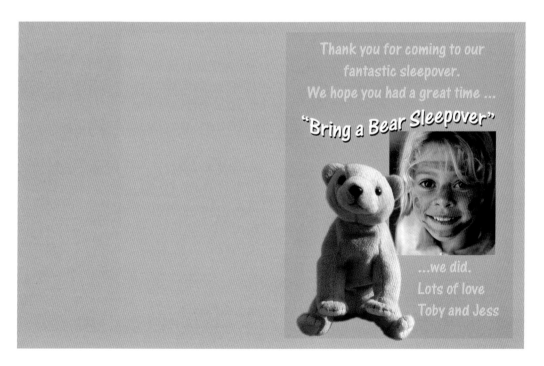

10 The finished card front will have to be folded when printed. If you lightly score the inside with a craft knife, this will help you achieve a clean, unbuckled fold. If you want to print a message on the reverse, set up another identically sized document and create the graphics, then print on the reverse side.

3

a birthday invitation

This project shows how easy it is to create a special effect like combining a child's head with an animal's body for an innovative birthday invitation.

Provided that both the child's and the animal's faces have been photographed from the same angle (preferably front-on as here), Elements will make light work of this task.

The technique is to use Elements' feathered selection (*see step 3* and *Tip Box on page 57*). This enables you to create a seamless blend between the two photos. If you intend to use 6 x 4in (15 x 10cm) perforated cards on which to print the invitations, remember to position all the visual elements to allow for the area outside the perforation to be removed (*see step 10*).

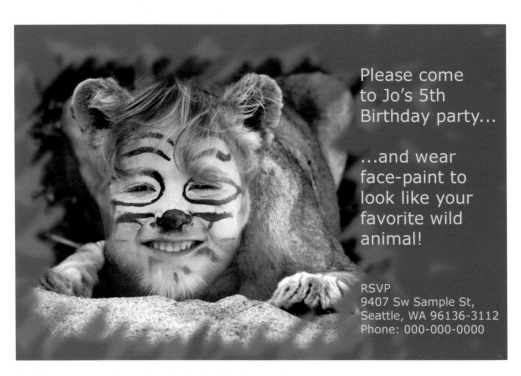

Please come to Jo's 5th Birthday party...

...and wear face-paint to look like your favorite wild animal!

RSVP
9407 Sw Sample St,
Seattle, WA 96136-3112
Phone: 000-000-0000

The finished project was trimmed to a 6 x 4in (15 x 10cm) shape. As this card will be mailed, it is sensible to give it waterproof protection using a spray available from your paper suppliers. The addressee details can be written on the reverse.

COMBINING THE IMAGES

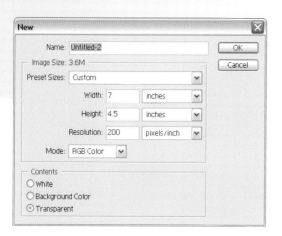

Select *New* from the *File* menu. Create a new document 7 x 4.5in (18 x 11.5cm), with a resolution of 200ppi.

Paste the wild animal and the child's face photos into the new document. Use the corner handles to reduce each image to a convenient size.

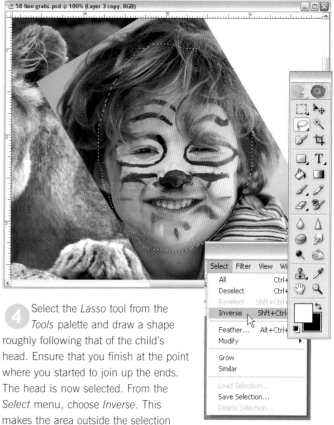

If the angles of the two faces don't match, as here, use the corner handles to rotate the child's face to match the lion. Make sure that the layer with the child's face is selected in the *Layers* palette.

 tip

Feathering a selection ensures that any selection made doesn't have a hard edge to it. This helps when you are combining images, as it helps to blend one image into another. The higher the radius of the feathering, the 'softer' the edge becomes.

Select the *Lasso* tool from the *Tools* palette and draw a shape roughly following that of the child's head. Ensure that you finish at the point where you started to join up the ends. The head is now selected. From the *Select* menu, choose *Inverse*. This makes the area outside the selection active rather than the head.

COMBINING THE IMAGES

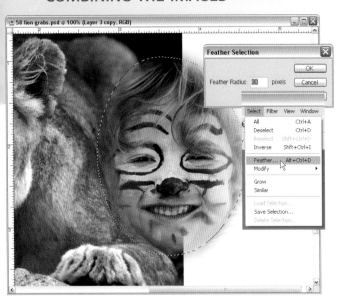

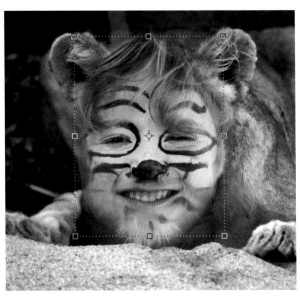

5 From the *Select* menu, choose *Feather* and set the *Feather Radius* to 30 pixels. Now hit the keyboard *Delete* key or use *Clear* from the *Edit* menu. The background has been removed from the child's face. It may be necessary to use *Delete* or *Clear* a second time to fully remove the background.

6 Using *Feather* in the previous step means that there is a soft, semi-transparent 'feather' around the shape rather than a hard edge. This allows part of the image below to show through. Now drag the child's face above the lion's face. Adjust the size and position using the corner handles.

ADDING A JUNGLE FRAME

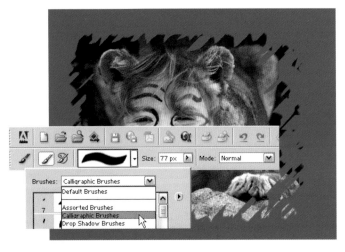

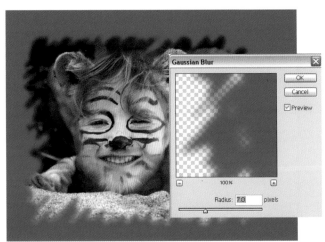

7 Select the *Brush* tool from the *Tools* palette. Then select *Calligraphic Brushes* from the *Options Bar* and choose 77px as the size. Select the *Foreground Color* from the *Tools* palette and make this green. Roughly draw in the jungle background on a new layer above the others.

8 From the *Filters* drop-down menu, select *Blur>Gaussian Blur* and adjust the *Radius* to about 7 pixels. The effect we are trying to simulate is looking through jungle leaves. Blurring helps to achieve this.

ADDING A JUNGLE FRAME

9 On a new layer above the others, repeat the drawing and blurring described in steps 7 and 8. This time, however, make the *Foreground Color* a little darker and don't fill in so much of the area.

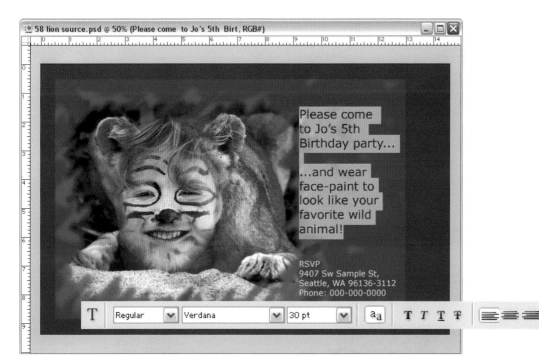

10 On a new layer above the others, select the *Horizontal Type* tool from the *Tools* palette and type in the message. We used Verdana at a point size of 30 in a pale yellow colour, which was sampled from the child's face using the *Eyedropper* tool. We reduced the font size to 20 point for the address details. If you are printing on 6 x 4in (15 x 10cm) perforated cards, keep the text within the area indicated by the darker border.

4
place cards

Creating place cards is a quick and easy project. All you need are some photographs of friends invited to a dinner party.

Cropping tightly into the face is more fun and dynamic than using a standard full portrait. If you want to be really radical, you could crop in further to a facial detail like the eye or mouth so the individual's identity is further disguised. Assembling all the photos as individual layers in one Elements document makes it easier to rescale and position them consistently. As most inkjet printers do not print to the edge of the paper, we have chosen to use a perforated 6 x 4in (15 x 10cm) photo paper. This is slightly oversize so that when the perforated waste is torn off, the print will be exactly 6 x 4in (15 x 10cm). If you prefer, use a larger size paper without perforations and then trim back to the required size.

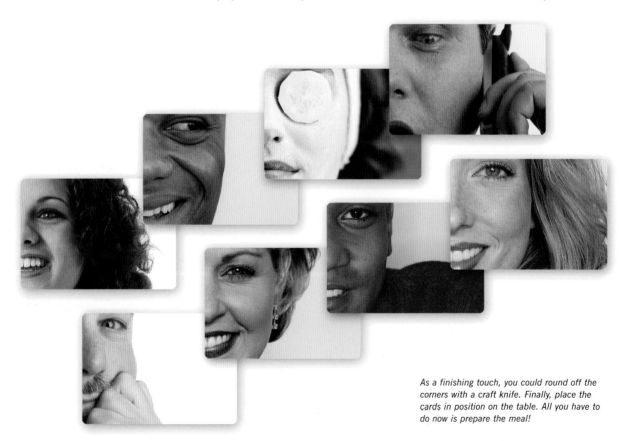

As a finishing touch, you could round off the corners with a craft knife. Finally, place the cards in position on the table. All you have to do now is prepare the meal!

PREPARING THE IMAGES

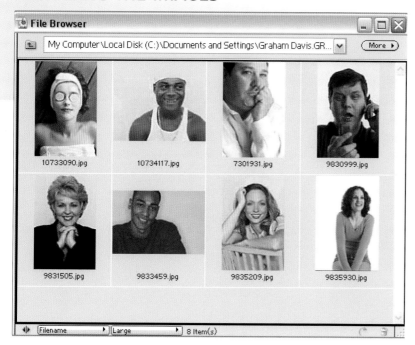

Using Elements' *File Browser*, select the photos that you intend to use for the project. Drag them onto the main window, and they will open automatically.

Select *New* from the *File* menu and create a new document 7 x 4.5in (18 x 11.5cm), with a resolution of 200ppi.

Using the *Move* tool, click on one of the photos and drag it onto the empty document that you have just created. This copies the image as a new layer. As the new document is smaller than the original and is also a landscape format, the image is cropped – just what was intended.

▶▶

PREPARING THE IMAGES

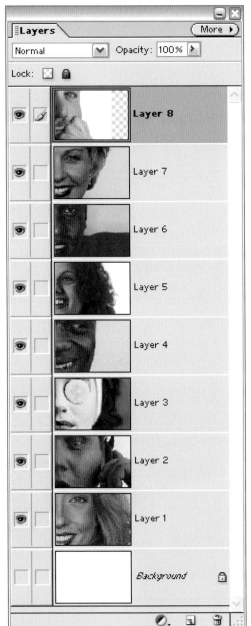

4 Drag the second image into the new document. As the face is bigger, it needs to be reduced so that it is about the same size as the first one. If you zoom out to 25%, the full extent of the original image will be visible. From the *Image* menu, select *Transform Image>Free Transform* and rescale using the corner handles. As you resize, hold the *Shift* key down to constrain the image to its original proportions.

Some images will need to be rotated to ensure the eyes are horizontal. Use *Free Transform* again. This time, positioning the cursor just outside the corner changes it to a *Rotate* icon. Use this to align the eyes. If necessary, the entire image can be moved by dragging from the centre point.

5 When all eight images are positioned, the *Layers* palette will look like this. Turn off the *Background* using the *Eye* icon. This will show you if any of the images on the other layers aren't big enough to cover the image area – as shown in *Layer 8* above.

6 Layer 8 needs some background added. Use the *Eyedropper* tool to sample the white background. This will now become the active foreground colour. Use a conveniently sized brush to paint over the area.

→ tip

Using templates

An alternative method of printing place cards from Elements is to use a blank MS Word document pre-formatted to enable two 6 x 4in (15 x 10cm) cards to be printed on a single A4-size card. You can download these templates from companies like Avery (http://www.avery.com). You should then print on a perforated card supplied by the same manufacturer to ensure an exact fit.

7 Printing on perforated 6 x 4in (15cm x 10cm) photo paper means $1/4$ inch (0.6cm) of the image will be trimmed off top and bottom and $1/2$ inch (1.3cm) off either end. To account for this, each face will have to be moved a similar distance to the right so that it is trimmed between the eyes. Turn on the required layer before printing and remember to turn the others off.

5

a holiday album

For this project, you will need to download either of the master file templates Vacation Album Special.psd or Vacation Album Plain.psd from the web-linked website (*see page 166*).

These holiday album templates have been created as A4 documents. You will be able to add your own photographs, then type in a new title and captions. If you start with the 'Plain' version, you will be able to add your own colours and effects. To give your project a more professional look, create a title that connects to your main photo.

Creating your own personal holiday photo album allows you to add text directly onto the printed pages, giving you the opportunity to add details and captions at will.

→ tip

printing layers

As you create more pages and thus more Layers, it is preferable to print each page when you finish it. You can then turn off the unwanted images and add those intended for the next page. Of course, any Layer can be turned on subsequently if you want to reprint it. If you find it tiresome working with many Layers, use the *Save As* command to create a carbon copy of the document and work on that as well. Always remember to use *Save* before *Save As,* or only the new document will reflect the changes made since you last saved it.

USING THE TEMPLATE

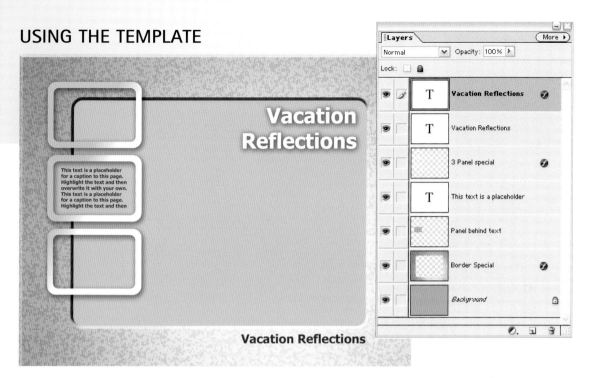

Open the Vacation Album Special.psd document. The screenshot shows one large panel and three smaller ones. Two layers, *Panel behind text* and *This text is a placeholder* are currently visible. These can be turned on or off, depending on whether you want to add text or another image.

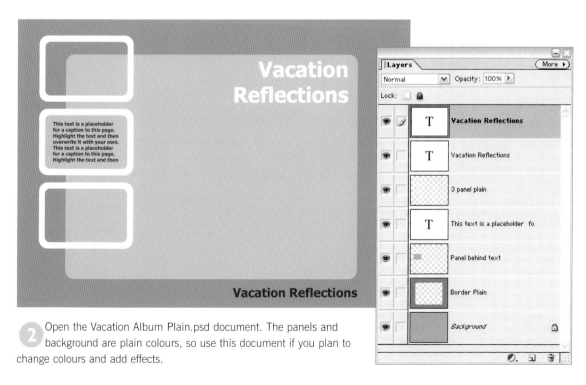

Open the Vacation Album Plain.psd document. The panels and background are plain colours, so use this document if you plan to change colours and add effects.

USING THE TEMPLATE

End of another glorious day

In the Vacation Album Special.psd document, add your own large photo on a new layer and use the *Transform* handles to resize and position it. Ensure the new layer is placed below the *Border Special* layer. Add three smaller photos on another new layer and use the *Transform* handles to resize and position them. Ensure that the new layer lies below the *3 Panel Special* layer. Turn off the *Panel behind text* and *This text is a placeholder* layers. This completes page one of the album.

Page two shows the *Panel behind text* and *This text is a placeholder* layers turned on. Add your own text here. New photos have been added so that they appear behind the two remaining panels. A new main image has been added below the *Border Special* layer. The main title layer has been turned off and the smaller one (bottom right) turned on.

Land Ahoy!

Food for the stomach and for the soul

Page three follows the process described in step 4, but this time the two smaller panels have been left blank. With a rigid design like this, a few pages that are different will make the project more interesting.

Page four continues the process of replacing photos and text. Try to give each page a theme. Even if it is somewhat contrived, it will add a professional touch.

ALTERNATIVE TREATMENTS

▲ Here, the default colours have been retained but the text on *This text is a placeholder* layer has been moved up to the top panel. The *Panel behind text* layer has been turned off so the corner of the image shows through.

▲ The theme here is obviously relaxation in the sun. Using candid shots gives your project an intimacy usually missing from posed ones. Select a colour scheme that reinforces the effect.

ALTERNATIVES

If you prefer to create a project based on the Vacation Album Plain.psd template, there are unlimited opportunities for customization.

▲ This album format can be used for any subject, not only holidays. Here it is used to display a collection of photos of the humble bench. One image has been split between two frames. The text has been changed to white and moved into the main frame. Create the border effect by selecting *Complex > White Grid* from the *Layer Styles* palette.

6
family portraits

Here we look at two very different ways of displaying your favourite family portraits. The floral frame uses a traditional border but is presented in a modern manner. The chrome frame is uncompromisingly contemporary. It uses a shape redolent of a classic car radiator or perhaps a piece of modern jewellery.

Both these projects use Elements *Layer Styles* extensively. These are a fantastic feature, but be sure that you use styles which match the character of the subject.

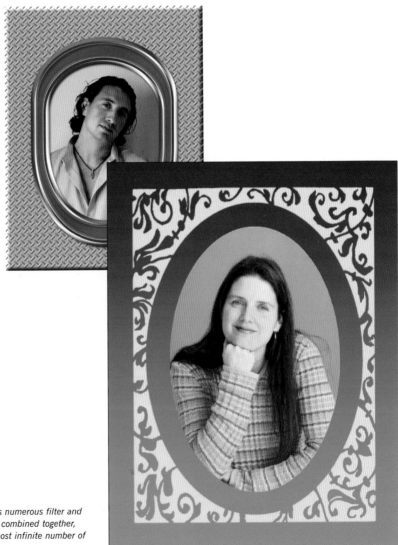

Photoshop Elements has numerous filter and layer effects that, when combined together, provide you with an almost infinite number of styles and treatments.

CREATING A FLORAL FRAME

1 Open a new 8.5 x 11in (21.5 x 28cm) document in Elements.

2 Either scan the floral frame or download it from the web-linked website (*see page 166*), paste it into the new document and turn off Layer 1.

3 Open your portrait image and copy it. Go back to the frame, create a new layer and paste your image into it. Drag the new image layer below the frame layer.

4 Use the *Transform* handles to scale the image to fit within the oval. Next, reselect the frame layer and from the *Tools* palette select the *Magic Wand* tool. Click inside the oval to create a selection and then choose *Inverse* from the *Select* drop-down menu.

5 With the selection made in step 4 still active, return to the photo layer and hit the *Delete* key. This removes the unwanted background. Return to the *Select* drop-down menu and *Deselect* the selection.

6 On a new layer below all the others, use the *Paint Bucket* tool to fill the layer with a background colour that harmonizes with the photo. The colour will show through, as the frame is transparent.

▶

CREATING A FLORAL FRAME

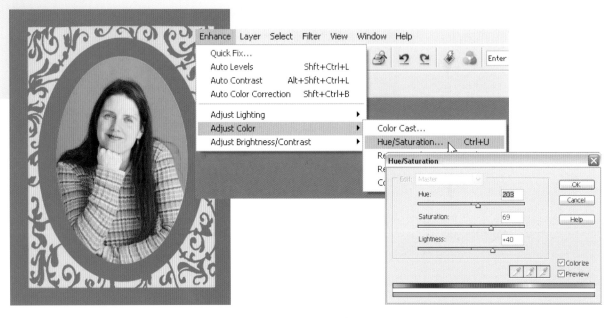

To change the colour of the black frame, select the frame layer. From the *Enhance* drop-down menu, select *Adjust Color > Hue/Saturation*. On the resulting dialog box, check *Colorize* and move the sliders to the positions shown. The frame becomes the colour shown in the bottom band of the box; here, it is blue. Adjust the sliders to select alternatives.

ALTERNATIVES

These images show the wide rage of one-click effects that can be achieved using *Layer Styles*. Apply them after completing step 7.

Soft Edge

Blue Ghost

Inner Ridge

Wow-Chro...

From the *Layer Styles* palette, select *Image Effects > Sun Faded Photo*. The frame will now have a graduated blue blend.

CREATING A CHROME FRAME

① Download and open chrome_frame.psd from the web-linked site. Turn off Layer 1 and turn on the frame layer. Open and copy your portrait image, then return to the frame document and paste your image. Next, follow steps 4 and 5 on page 69.

② Select the frame layer. From the *Layer Styles* palette, select *Wow Chrome > Beveled Edge*. The default setting applies a thin bevel to the frame.

③ Double-click the small *Layer Styles* icon in the frame layer. This opens a *Style Settings* palette. Drag the *Bevel Size* slider up to 65 to increase the bevel size.

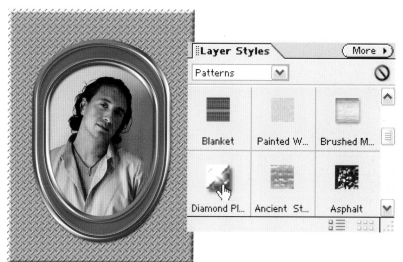

④ Select the Background layer. Using the *Paint Bucket* tool, fill the background with black.

⑤ To complete the effect, select *Patterns > Diamond Plate* from the *Layer Styles* palette.

7

a family tree

This is another project that uses a simple master file template from the web-linked website (*see page 166*). It has been created as an A4-sized document.

You can adjust the family tree template at will. You can type in a new title and the correct family member details, then add pictures of each of them. You can also add your own background photo to create a very professional-looking and personalized family tree. The tree includes spaces for you and your partner, your parents, grandparents, great-grandparents and three children. If you have a different number of offspring, simply adjust the *Image Placeholder* and *Link Lines* layers.

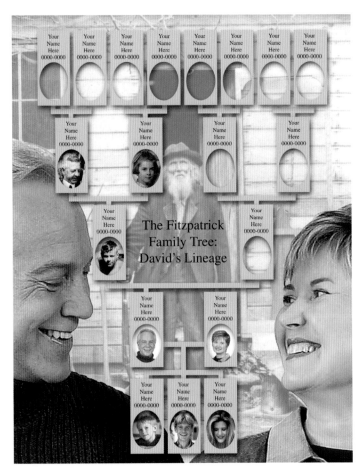

A personalized family tree is great fun to make, and will provide you with a unique record of your genealogy that you can share with family and friends.

FAMILY TREE

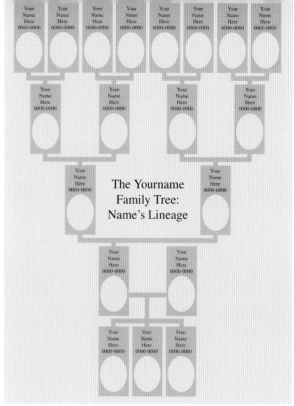

THE MAIN TITLE LAYER ⎯⎯⎯⎯⎯⎯

THE 19 TEXT LAYERS, ONE FOR EACH RELATIVE'S NAME AND DATES ⎯⎯⎯⎯⎯⎯

HUE/SATURATION ADJUSTMENT LAYER
(this applies only to the Image Placeholder) ⎯⎯⎯⎯⎯⎯

IMAGE PLACEHOLDER LAYER ⎯⎯⎯⎯⎯⎯

HUE/SATURATION ADJUSTMENT LAYER
(this applies only to the Link Lines) ⎯⎯⎯⎯⎯⎯

LINK LINES LAYER ⎯⎯⎯⎯⎯⎯

HUE/SATURATION ADJUSTMENT LAYER
(this applies only to the Background Colour) ⎯⎯⎯⎯⎯⎯

BACKGROUND COLOUR LAYER ⎯⎯⎯⎯⎯⎯

BACKGROUND ⎯⎯⎯⎯⎯⎯

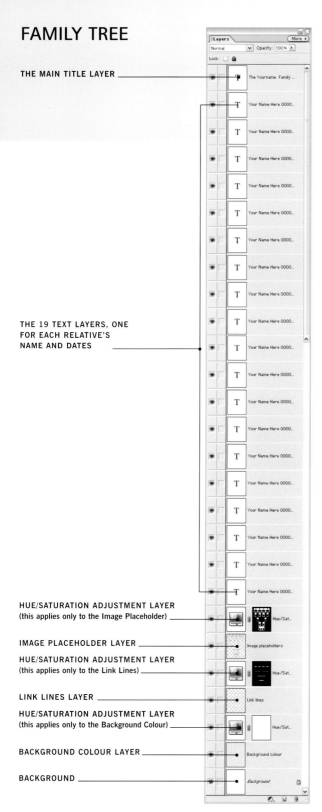

1 Open the Family Tree.psd document. From the *Palette Dock,* drag off the *Layers* palette. This ensures that the *Layers* palette stays open. Expand it to the maximum depth available on your screen. Use the scroll bar to show the layers at the bottom. The master file is ready for you to add your personal details. Clicking the layer thumbnail of any *Hue/Saturation* adjustment layer will open a dialog box that enables you to easily change the colour of the layer below it. *(see Alternatives box on page 75).*

2 If you wish to repeat the project based on your partner's lineage, use the *Rectangular Marquee* tool to select the link and drag it to the correct position before adding their details. ▶▮

FAMILY TREE

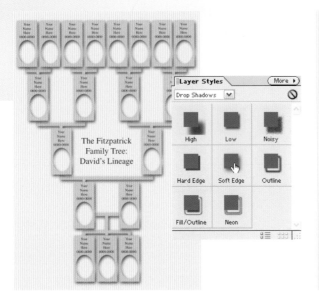

3 With the Image Placeholder layer selected, click on *Drop Shadows > Soft Edge* from the *Layer Styles* palette. Repeat this process for the Link Lines layer. Both will now have a shadow behind that 'lifts' them from the page.

4 Add a new layer immediately below the Link Lines layer and paste in the first photo. Use the *Transform* handles to rescale and reposition it to fit within the frame.

5 To remove the unwanted area of the image, first use the *Rectangular Marquee* tool to define the area. Then choose *Inverse* from the *Select* drop-down menu. Hit the *Delete* key, and the unwanted area will disappear.

6 Continue adding the remaining photos, following the process described above.

FAMILY TREE

7 When adding previous generations to the project, the images are likely to be black-and-white. If you wish to add a sepia tone to them, select *Photographic Effects > Sepia Tone* from the *Layer Styles* menu.

8 If you wish to add an overall image to the project, ensure that it is pasted in above the Background Colour layer. To add colour to the image, double-click on the layer thumbnail of the *Hue/Saturation* adjustment layer. You can apply a colour (here we have used blue) by using the sliders.

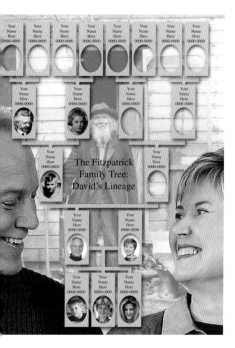

ALTERNATIVES

It is very easy to change any of the project colours if you have downloaded the Family Tree.psd document.

Change the colour of *Image Placeholder* and *Link Lines* by clicking the Layer thumbnail of the relevant *Hue/Saturation* adjustment layer. Here, it has been changed to blue.

9 You may wish to add an image of yourself and your partner. Paste it into a layer above the layer described above, or this image too will be blue. To allow the image in step 8 to show through, delete the background in the photo of you and your partner (*see pages 31 and 53*).

If you prefer to use a darker background image that results in the title being illegible, it could be split into two parts and the colour changed to white, as here. If you have access to a wider range of fonts, using an italic one like Caslon creates a professional look.

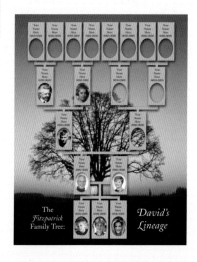

8

a scrapbook

EJ is a keen photographer who wants to make the most of images taken over a number of years. Rather than simply group images by place or family EJ has built a scrapbook based around themes like this one, which features some quirky images of signs.

Ideally for this project, you need an A3 printer; but don't worry if you haven't got one, as it can be printed to fit A4 if the larger option is not available, or if you'd rather not use a high-street developer or print shop. Depending on the binding methods available the pages can be bound at the left with, for example, a plastic binding strip or staples. Another option is to crease each page 2 inches (5cm) in from the left so that the pages hinge at the join of the blue strip and orange background.

The next time you go on holiday, as well as the group photos of family and friends sitting around the pool or relaxing on the beach, think of a theme, such as wildlife, architecture, or neon signs, that you can photograph; these can often make for an unusual and unique record of your time away.

DIGITAL PHOTO SCRAPBOOK

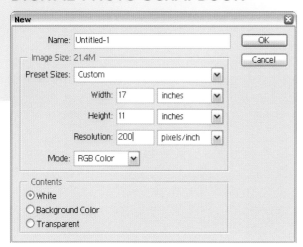

1 Open a new 17 x 11in (43 x 28cm) landscape document in Elements. If your printer is unable to print at this size select the *Scale to Fit* Media option from the *Print Preview* menu, when you want to print the finished project.

2 Assemble the photos that you want to use for the project and paste each of them into the new document. On a new layer below the photos use the *Rectangular Marquee* tool to create a 2-in (5-cm) wide selection on the extreme left and fill with colour – we used blue.

3 Use the *Color Picker* to change the foreground colour to orange. From the *Tools* palette select the *Pencil* tool and then from the *Options Bar* change the size to 16px. On a new layer, hold the shift key down and draw a horizontal line across the entire width of the document and repeat the process for a vertical line. Use the rulers (*View > Rulers*) to obtain the correct position – 5.5 inches (14cm) vertical and 9.5 inches (24cm) horizontal.

4 From the *Layers Styles* palette select *Bevels > Simple Sharp Pillow Emboss*, this gives the lines a 3D effect.

▶▌

5 On a new layer below the border layer use the *Paint Bucket* tool to fill the layer with the same orange colour that you used in step 4.

6 Select *Render/Lens* flare from the *Filter* menu and drag the flare centre cross down to produce a horizontal flare, adjusting the *Brightness* setting to 142. You have now created four equal compartments in which to display your photos.

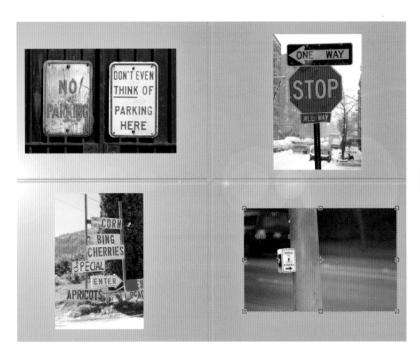

7 Select and rescale each image to fit comfortably within each compartment, it will look more professional if the image size is consistent.

→ tip

Positioning the images

Most printers leave a small margin of white paper around the edge; don't forget to allow for this when positioning the photos. It might be helpful to create a new layer with $1/4$-in (0.6-cm) margin filled with a contrasting colour, (for example red). This layer can be deleted when you have finished positioning the photos.

8 With one of the photos still selected, choose *Drop Shadows/Soft Edge* from the *Layer Styles* menu, and repeat this to the other photos.

9 On a new layer (moved to the top) use the *Horizontal Type* tool to type in the title, we used 112 point Garamond Bold, then use the *Transform* handles to rotate the title. Holding down the Shift key will help find the vertical position.

10 Use the *Layers Style* described in step 8 to apply a drop shadow to the title and position it within the blue panel. When you have printed out the first sheet, turn off the four original photo layers and turn on four others; don't forget to apply the drop shadow to the new ones.

11 For the title page of your scrapbook, select a really strong image and try to match it with a catchy title. A finishing touch is to apply a pattern over the orange background. With the foreground colour set to white, from the *Tools* palette choose the *Custom Shape* tool and select *Grass 1* from the *Nature* category. On a new layer, hold down the mouse button and drag the cursor starting top left to bottom right. From the *Layers* palette select the *More* button and choose *Simplify Layer*, and reduce the *Opacity* to 25%.

9

a photo story

Saving the memories of a family day out is a straightforward task with Elements. This project is enhanced by the addition of the boot-print background and the hand-drawn graphic of the river. These are both easy to create.

The addition of captions to the photo story helps to personalize the result and record the journey along the banks of Cooper's creek. If you are uneasy about drawing the course of the creek directly in Elements, you could draw it on paper first. Then scan it, paste it into the Elements document and, using this as a guide, trace over it on a new layer with the *Brush* tool. This is another 17 x 11in (43 x 28cm) project. If your printer is limited to a smaller size, use the *Scale to fit media* option.

On the trail to Cooper's Falls

Trekking with the Travis family
From Hayward Bridge to Cooper's Falls
16 May 2005
The Team:
Mom and Dad, Gramp's, Rachel, Gina
and Peter Travis (that's me)

8.40 Mom doesn't seem too sure of Dad's map reading skills

11.50 No stopping these young-uns

12.10 Gramp's feet are sore but he doesn't seem to mind

1.25 Cooper's Falls at last

9.10 Pure water; but how do you get it?

8.00 Setting off

10.10 We reach the "Silent Pool" just 10 minutes behind schedule.

10.45 Someone has to check out the stones!

12.25 Just checking my GPS; what do you mean it looks like a Gameboy?

1.10 Wow! Do you think this is avalanche damage?

Instead of printing out individual photos as a record of a day's hiking, it's more effective to select the strongest images and place them on one large page with dates, times and captions that chart the day's events.

COOPER'S CREEK PHOTO STORY

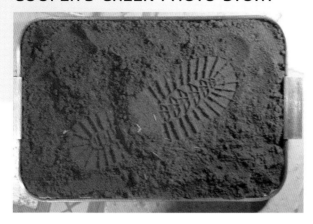

1 A boot print in soft sand forms the background to this project. The boot was pressed into a tray of coarse sand. This was photographed with a hand-held camera without flash using natural light, but with an angle poise lamp providing the strong side-lighting. The quality of this image is not too important, as it will be manipulated in step 3.

2 Open a new 17 x 11in (43 x 28cm) document in Elements. Paste the boot-print photo into the new document. Using the *Transform* handles, drag it to a convenient size to fill the entire background.

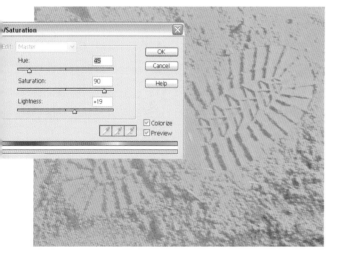

3 Click the *Create new fill or Adjustment Layer* icon at the base of the *Layers* palette. Choose *Hue/Saturation*, then check *Colorize* and drag the sliders to the values shown above. With *Colorize* checked, the image becomes the colour shown in the bottom band of the dialog box. In this example, it is a mid-tan colour.

4 On a new layer above the previous one, select the *Brush* tool from the *Tools* palette. From the *Options Bar*, use a default hard-edged brush, but change the size to about 77px. This will be the thickness of the line. Select a deep blue as the foreground colour and draw the river in one fluid movement. If you make a mistake, simply undo and try again.

►►

5 Having assembled the images to be used in this project, paste the first one into position. You will need to reduce the size of each image using the *Transform* handles. Hold the *Shift* key down while doing so to avoid distorting the image.

6 Continue pasting and resizing each image until they are all in position.

7 The images that you have pasted in are all on separate layers. Select each layer in turn and, from the *Layer Styles* palette, select *Soft Edge* from the *Drop Shadows* menu.

8 Create a new layer above the others for the heading text. Use the *Horizontal Type* tool to type in the title. Here, we have used Nueva Bold Condensed at 50 point.

COOPER'S CREEK PHOTO STORY

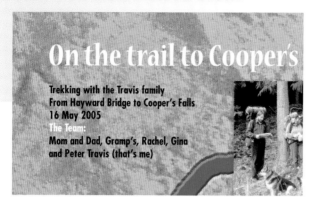

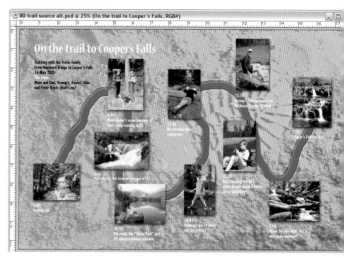

9 Create another new layer above the others. Then use the *Horizontal Type* tool type in the subhead. Here, we used Futura Bold Condensed at 16 point.

10 On another new layer, add a caption to the first image, using the same type style as the previous step. Continue this process until all the captions are complete. As each will be on a new layer, your document will now have a lot of layers. You will have to scroll up and down the *Layers* palette in order to select them.

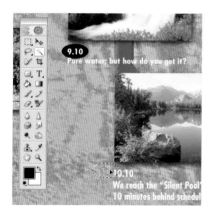

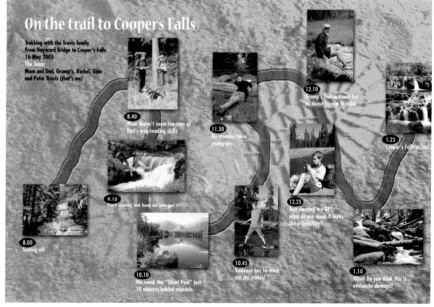

11 On a new layer below all the caption layers, use the *Elliptical Marquee* tool from the flyout menu on the *Tools* palette and draw an oval. Use the *Paint Bucket* tool to fill it with black. Use the *Magic Wand* to reselect the oval shape and drag it to the next position. Ensure the *Magic Wand* is still selected as you drag the oval. This ensures that the first black oval is not moved as well. Fill the second oval with black, and continue until all are completed.

12 As a finishing touch, select the rivers layer and, from the *Layers* palette *Blending Mode* drop-down menu, select *Linear Light* rather than the default *Normal*. This allows some of the background image to show through.

10
a calendar

This project is A4 size but it can be printed to fit a larger (A3) format. Before starting, check on the amount of border that your printer leaves; if it is more than a quarter inch (0.6cm) then make the frame a little wider than the one inch (2.5cm) specified in this project.

The pages for the calendar are assembled in one multi-layered Photoshop Elements file. This enables the consistent alignment of text and images to be easily maintained. As Elements is an image-editing application, it does not have very sophisticated paragraph text-handling features. To overcome this limitation, the font used for the calendar dates is italic. This makes any slight misalignment of the columns less noticeable than it would be if a regular font were used.

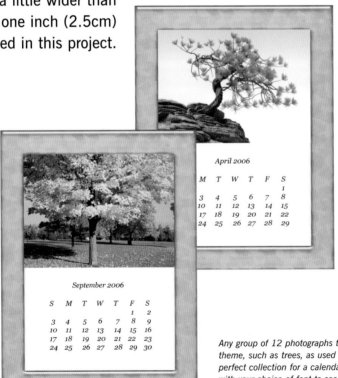

Any group of 12 photographs that have a similar theme, such as trees, as used here, make a perfect collection for a calendar. Play around with your choice of font to see which suits the subject matter best.

TREE TOPIA CALENDAR

① Open a new document in Elements using an 8.5 x 11in (21.5 x 28cm) in portrait format.

② On a new layer using the *Rectangular Marquee* tool create a selection 1 inch (2.5cm) in from the edge of the page. Choose *Inverse* from the *Select* menu.

③ Use the *Paint Bucket* tool to fill the selection with black to create a 1in (2.5cm) border around the page.

④ Select *Wow Plastic* from the *Layers Styles* menu. This effect is semi transparent – a quality that we will utilize in the next step.

▶▶

With the *Brush* tool selected, choose *Falling Ivy Leaves* from the *Options* menu and change the size to 120px.

Ensure the foreground colour is still set to black and on a new layer below the frame use the *Brush* tool to paint in the leaves under the border. It may take a few attempts to get it right and you can add single leaves with a single mouse click.

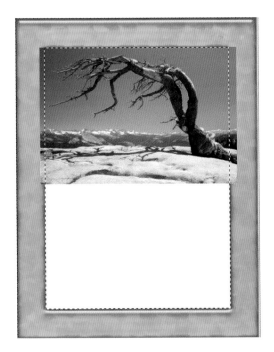

Select the border layer, and using the *Magic Wand* tool make a selection inside the frame. Return to the leaves layer and hit the delete button, this trims away the unwanted leaves.

On a new layer (above the frame) paste in the first of the photos to be used to illustrate the months of the year. Repeat the selection process in step 7, but this time choose *Inverse* from the *Select* menu. Hit the delete button and the excess image will be removed.

TREE TOPIA CALENDAR

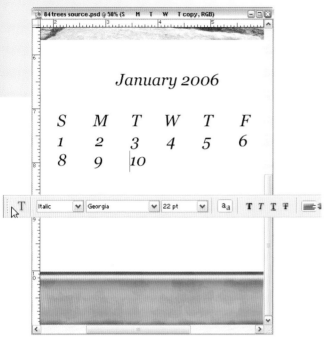

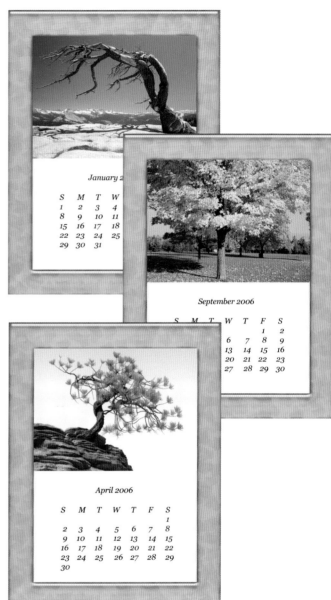

9 On a new layer select the *Horizontal Type* tool and choose the font Georgia italic at 22 point. Type in the month name. Allow a line space and then type in the initial letter of each day. As Elements does not have a tab function, use the keyboard spacebar to achieve the desired position of each letter. Continue typing in the dates using the same method of alignment.

→ tip

Cover page

To finish off the project a cover page is desirable especially if it is to be a gift. As it will not be displayed for long, if at all, a simple typographical page has been used. The title is the same as the font used for the dates but at 88 point. The *Eyedropper* tool has been used to sample a pale brown from the frame.

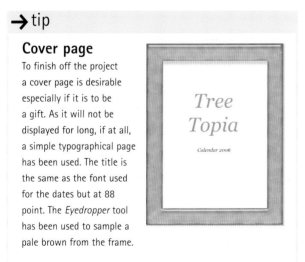

10 Adjust the position of the date text so that it sits comfortably beneath the photo and then repeat the process of adding new images and the appropriate dates for each month. To avoid creating too many layers in one document, you may prefer to split the year into two or three documents.

11

personal stationery

The personal letterhead on page 89 contrasts with the business version on pages 90 and 91. Both versions, however, reflect the character of the people or company they represent.

Although it may be possible to use existing photographs for personal stationery, a more professional result is likely if you shoot the photos with the eventual design in mind. The personal letterhead uses photos of Jane and Michael and their home. The business letterhead is uncompromisingly contemporary, with a specially created logo and some graphics added to the background along with a photo of the proprietor shot in profile.

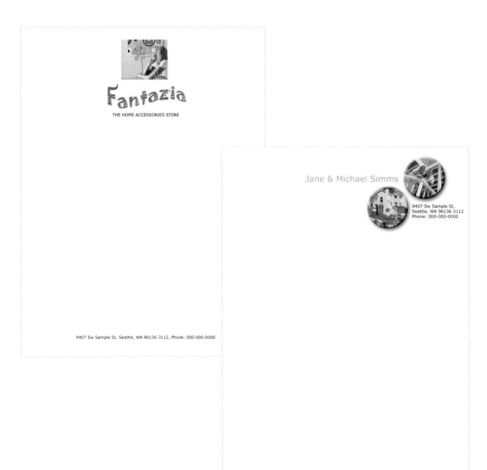

Creating your own personal or business stationery can have a strong impact on the people with whom you correspond, and doing it yourself will save you lots of money!

CREATING A PERSONAL LETTERHEAD

1 Open a new document in Elements, A4 size will work fine. Paste in the two photos that you are using for the letterhead. Select the *Elliptical Marquee* from the *Tools* palette. Drag it over one of the images until you are satisfied with the crop. Now choose *Inverse* from the *Select* menu and then *Cut* from the *Edit* menu. This will delete the unwanted image area, leaving the remainder within a circular shape.

2 Repeat the process with the other photo and then drag each to their desired position at the top right area of the letterhead. Each photo is on a separate layer.

3 Select one photo. From the *Layer Styles* palette, select *Bevels > Simple Inner* and *Drop Shadows > Soft Edge*. This creates a three-dimensional button effect and adds a small round icon to the layer in the *Layers* palette.

4 To fine-tune the bevel and shadow, double-click the icon in the *Layers* palette and make any adjustments that you require. Repeat this process with the other photo.

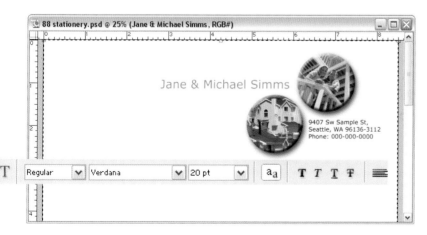

5 On a new layer, select the *Horizontal Type* tool from the *Tools* palette and type in the names. We have used Verdana at 20 point size and used the *Eyedropper* tool to select a brown colour found in the photos. Add the address details on a new layer and adjust the position of all the elements until they form a satisfactory design.

6 The finished letterhead looks professional. The colours are muted, and the address details are simply black and set in 10 point.

CREATING A BUSINESS LETTERHEAD

1 Open a new A4 document in Elements. On a new layer, use the *Rectangular Marquee* tool to draw a rectangle. Use the *Paint Bucket* tool to fill it with a colour (here, yellow) to match the photo that you intend to use.

2 Deselect the selection. From the *Filters* palette, select *Distort > Wave* from the drop-down menu. Click the *Apply* button. On the next palette, configure the *Wave* until you are happy with the result in the preview. Keep the two *Scale* sliders to the same value to obtain a result that is balanced on all sides. Then click on the *OK* button. The result should look like this.

3 On a new layer above, paste the photo in a central position about $1/2$in (1cm) from the top. Scale it using the *Transform* handles until you are happy with the size.

4 On another new layer, use the *Horizontal Type* tool to enter the company name. Here it is 'Fantazia'. If you do not have a font like Jokerman, used here, you could search on the Web for free fonts. You will soon find hundreds. The colour is irrelevant, as we will add a special finish to the logo in a later step.

BUSINESS LETTERHEAD (FANTAZIA)

5 With the text still selected, choose *Create Warped Text* from the *Options Bar*. From the *Style* drop-down menu, select *Wave*. Click OK to use the default settings.

6 From the *Layers Style* palette, select *Wow Chrome Bevelled Edge* from the *Wow Chrome* drop-down menu. The result is a fantastic 3D chrome effect on the logo.

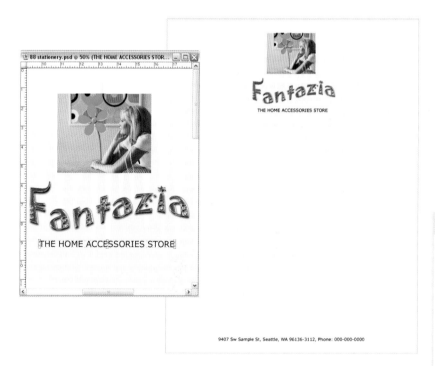

9407 Sw Sample St, Seattle, WA 96136-3112, Phone: 000-000-0000

7 On a new layer, add the subhead in Verdana caps. The size here is 10 point, using black as the colour. The final step is to add the address details, centred at the bottom of the page.

→ tip

Folding the letterhead

The main letterhead imagery should be kept within the top third of the page so that when it is folded it sits comfortably in this area. Place the folded letterhead in an envelope to check that the top third is visible when the envelope flap is torn away.

special print projects

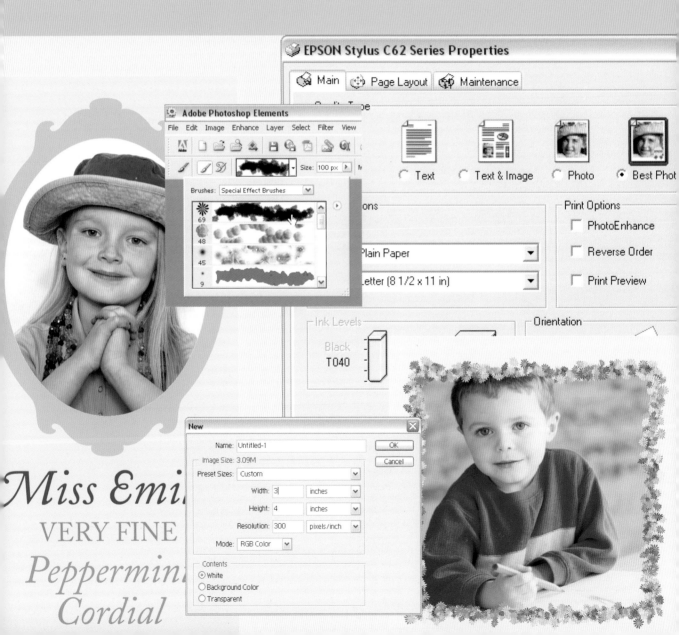

The desktop inkjet printer has become ever more versatile, printing on a wide range of media in addition to straightforward paper. Most of the techniques covered in this special print projects section are readily achieved as long as you prepare your digital files properly and follow the printing and finishing instructions for each type of media. Of course, you may prefer to have a professional printer undertake the printing for you. If so, see the guidelines on page 160.

CHAPTER CONTENTS

12
t-shirts

This project demonstrates how easy it is to print and then transfer an image to a t-shirt or other fabric.

The image is first printed onto a special transfer paper. This is then ironed onto the fabric. Due to the heat involved, you should use a fabric with at least 50% cotton content. The transfer process will mirror the image, so the image needs to be flipped horizontally in your image-editing program to maintain the original view. If you prefer to have your t-shirt printed professionally, the box below gives some guidelines.

what you need

- transfer paper
- inkjet printer
- household iron
- scissors
- a flat surface to work on
- a t-shirt

CREATING THE TRANSFER

Happy 18th Birthday
Maria

1 Open a new A4 document in Elements. Create two new text layers and type in the name and message of your choice. Here the word 'Maria' is in red, a colour that we will use on the frame later on. The font is Pablo. You will have to substitute it with a font available on your own computer.

HAPPY BIRTHDAY T-SHIRT

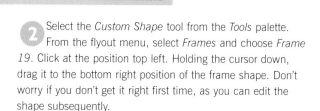

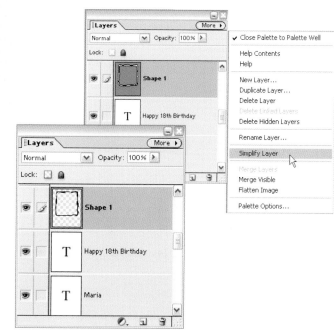

2 Select the *Custom Shape* tool from the *Tools* palette. From the flyout menu, select *Frames* and choose *Frame 19*. Click at the position top left. Holding the cursor down, drag it to the bottom right position of the frame shape. Don't worry if you don't get it right first time, as you can edit the shape subsequently.

3 When you draw with the *Custom Shape* tool, a new shape layer is created. To convert this to a regular Layer on which you can apply effects, click on the *More > Simplify Layer* button on the layers palette. The *Layer* icon now has a chequerboard background indication that it is transparent.

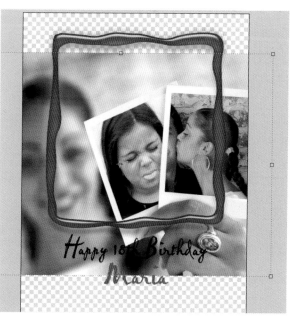

4 With the Shape 1 Layer still selected, choose *Wow Plastic > Red* from the *Layer Styles* palette. This effect is now applied to the frame.

5 Paste in the photo to be used within the frame. Use the *Transform* handles to rescale and position it so the area to be shown within the frame is correct.

▶▶

HAPPY BIRTHDAY T-SHIRT

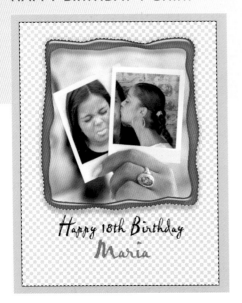

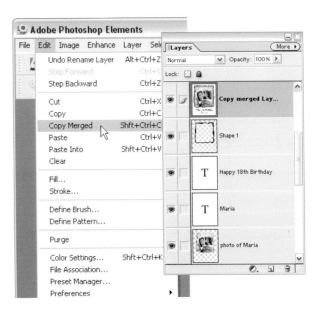

6 Once you are satisfied with the position of the photo, reselect the Shape 1 Layer. Using the *Magic Wand* tool, click in the area outside the frame. Now return to the Photo Layer and hit the *Delete* button. This removes the unwanted portion of the photo.

7 Select the topmost Layer. From the *Select* menu, choose *All*. Then choose *Copy Merged* from the *Edit* menu. This action makes a copy of all the visible layers, including the background. Again from the *Edit* menu, select *Paste*. The new Copy merged Layer is now at the top of the order.

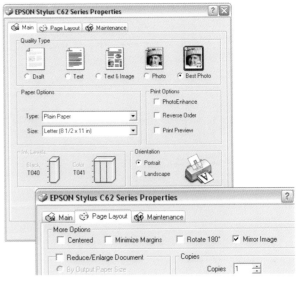

8 From the *Image* menu, select *Rotate > Flip Selection Horizontal*. This converts it to the mirror image that is necessary for the image to appear correctly when it is transferred onto a t-shirt.

9 Steps 7 and 8 can be ignored if your own printer is able to print a mirror image. The option may not be on the *Main* options tab. Follow the transfer paper manufacturers' instructions before starting to print. Usually the best quality is the suggested option.

HAPPY BIRTHDAY T-SHIRT

→tip

Use the template instead

You can download the
Tee Shirt.psd document
from the web-linked website
(see page 166) and simply
add your own text and photo.

ironing the print-out onto the t-shirt

These instructions are for a typical
transfer paper, Epson Iron-on Cool
Peel Transfer Paper. Other makes may
be different, so read the instructions
carefully before proceeding.
Although transparent, the unprinted
background will be apparent where
the texture of the fabric has been
ironed. If your image is an irregular
shape, you may prefer to trim the
print back to within a quarter of an
inch of it so that this is less
noticeable.

❶ Make sure the t-shirt is free from
wrinkles. Place it face up on a
hard, flat surface that is able to
withstand heat, such as a sheet of
wood or a laminate worktop.

❷ Place the transfer print-out face
down on the t-shirt in the position
that you want it to appear.

❸ Ensure that the steam setting is
turned off. Heat the iron to
high/max temperature – usually
between 350 and 390° F (180 to
200° C). Cordless irons may not
retain heat long enough to
complete the process.

❹ Apply steady pressure and heat as
you iron over the surface of the
print-out. This will take between
45 seconds and 1 minute. If you
have some spare fabric, it is
sensible to do a test transfer with
a spare print-out.

❺ Leave to cool for a couple of
minutes and then carefully
peel away the transfer paper,
leaving the image imprinted on
the garment.

10 To convert to JPEG format, select *Save As* from the *File*
menu and choose *JPEG* from the drop-down menu.
Leave the options as default, which should be *Quality* at 12
Maximum. The resulting file will be about 1.6MB. If you
reduce the quality setting to 6 Medium, the file size will be
considerably smaller without much loss of quality.

11 A typical online print service has a browse button to
enable you to select the image to be uploaded to the
online printer.

13
fridge magnets

Magnetic backed paper can be used without any special preparation. For most projects, the prints are cut to size after printing, although it is possible to print a full A4-size project if you wish.

We have chosen a 4 x 3in (10 x 7.5cm) size. This enables six items to be printed on a single sheet of A4 paper. Put your digital photos to good use in projects like this playground safety reminder or a homespun motivational message.

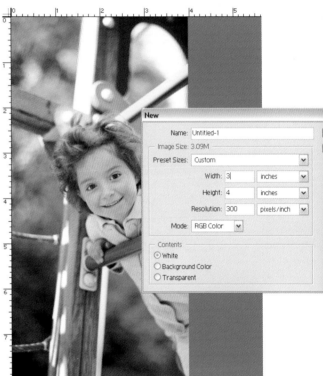

Open a new document in Elements, 4 x 3in size. Paste in the photo. In this example, we moved the image to the left, leaving a margin on the right-hand side, as this will be covered by a green panel. On a new Layer above the photo, use the *Rectangular Marquee* tool to define a panel. Then sample a colour from the image from the photo, using the *Eyedropper* tool. Fill it using the *Paint Bucket* tool. We used a green (R 32, G 116, B 38).

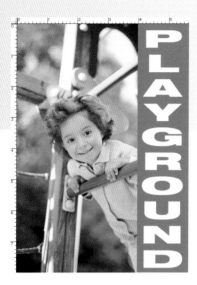

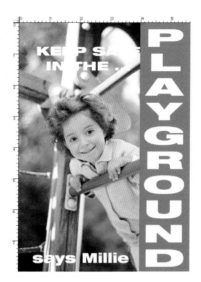

2 On a new Layer above, use the *Vertical Type* tool to type in the title. We used Helvetica Black Extended at 57 point; you will have to use a font available on your computer. Use the *Transform* handles to distort the text so that it fits the panel shape. Try to avoid extreme distortion, or the text will be hard to read.

3 On two new layers above, type in the remaining text using the same font as the main title. Don't worry too much about exact positioning, as this can be changed later.

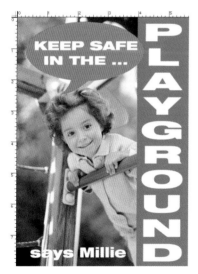

4 Select a new Foreground colour by sampling another colour from the photo. For the speech bubble, we chose a red that stands out well against the photo and green panel. Select a *Talk Bubble* from the *Custom Shape* tool options and draw a shape on a new Layer below the text but above the panel. This will assume the Foreground colour that you have just selected. Allow the bubble to overlap the panel a little. Adjust the text and bubble size until both are correct.

5 Chose *All* from the *Select* menu and *Copy Merged* from the *File* menu. Open a new A4 document. Paste in the merged image. If you want to duplicate this magnet, paste the image another five times and rearrange the images to fit the page. Alternatively, you could create several magnet projects and paste a variety of images into the new document. Follow the printing instructions for the magnetic paper. It is normally the same as regular paper.

14

water slip decals

For this project, you will need a white ceramic plate on which to apply your decal. The area for your decal should be flat to avoid creasing when the decal is applied.

what you need

- water slip decal paper
- inkjet printer
- lint free cloth
- dish of water

Any subject can be suitable, but this plate is intended for mounting on a wall, so it is best to choose something that you are unlikely to tire of – like our dog, Monty.

1 Open a new document in Elements. It can be any size as long as it is not smaller than the area of the plate that you intend to fill. We chose 12 x 12in (30.5 x 30.5cm).

2 On a new Layer, use the *Elliptical Marquee* tool to define a circle. Choose *Inverse* from the *Select* menu and fill the circle with white using the *Paint Bucket* tool.

MONTY
No.1 Pooch

3 On a Layer below, paste in your photo. Use the *Transform* handles to rescale the image. The image that we chose has an obvious space for the title; your image needs to be carefully chosen with this in mind.

4 Duplicate the Layer created in step 2. Use *Adjust Color > Hue/Saturation* from the *Enhance* menu. Select a colour for the image's border. Drag this new Layer below the white one. It will temporarily disappear.

5 With the image still selected, use a corner *Transform* handle to reduce the size of the image. It will now become visible beneath the Layer above. Hold down the *Shift* and *Alt* keys together while you do this so the image will rescale from its central point.

6 Use the *Magic Wand* tool to make a selection within the circular window. Choose *Inverse* from the *Select* menu. Again from the *Select* menu, choose *Feather*. The actual amount will depend on the size of your image. Between 16 and 64 should be fine.

7 With the selection still active, change to the photo layer and hit the *Delete* key. This will remove the background of the image, leaving it with a soft (feathered) edge.

8 On two new layers above the others, type in the title and subtitle. We used Caslon semi-bold small caps and italic; you will have to use fonts available on your computer.

printing and applying the decal

Follow the water slip decal printing and application instructions supplied with the paper. They are likely to be similar to these.

❶ Make sure the paper is placed in the printer tray correctly and print with high-quality setting.

❷ Leave the print to dry for a few minutes and then spray with a clear varnish. Several coats will be required. Leave each to dry before applying the next. This is important beacause the varnish fixes the inkjet print-out, which would otherwise run in contact with water.

❸ Cut out the circular image with scissors or a craft knife. Place it in a dish of water for about 30 seconds, or until you can feel the thin membrane slipping away from the backing paper.

❹ Apply some watery glue (diluted PVA) to the area where you are going to place the decal. Then slip off the design from the backing paper and onto the plate. Drain off the water. Smooth out the design with a lint-free cloth to remove the air bubbles. When thoroughly dry, you can spray-varnish the completed design if you wish.

15
fabric

An alternative to printing on a transfer paper that is then ironed onto a fabric is to print directly onto special cotton fabric sheets.

Special fabric sheets are normally A4 size, but you can trim them down to a square if you wish. This would be ideal for a traditional-style quilting project. If prepared properly, the printed fabric should be colour-fast and washable.

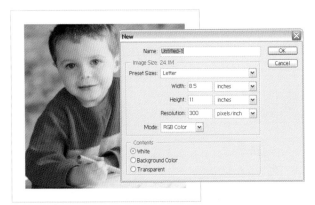

Open a new document in Elements, $8^1/_2$ x 11in (21.5 x 28cm) size, and paste in your photo. Use the *Transform* handles to resize it. Trim off the top and bottom to leave a square shape.

Select a suitable colour for the background of the page. With the *Paint Bucket* tool selected, fill the entire background.

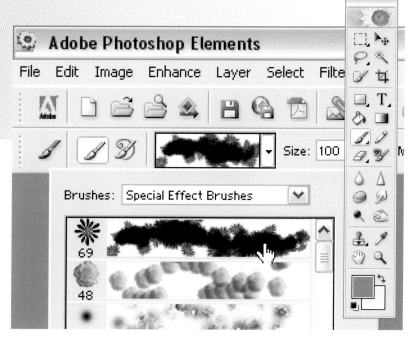

printing and applying the decal

Follow the fabric sheet printing instructions supplied with the paper. They are likely to be similar to these.

❶ The backing sheets must be totally secure before printing. If in doubt, iron them first.

❷ Make sure the paper is placed in the printer tray correctly and print with high quality setting.

❸ Leave to dry for at least 30 minutes. Then iron for about 1 minute before peeling off the backing sheet. The fabric is now ready for a quilting or other project.

❸ Switch Background and Foreground colours, using the icon at the bottom of the *Toolbox*. Select a new Foreground colour to match a colour in the image. Now select the *Brush* tool and pick *Azalea* from the *Special Effect Brushes*.

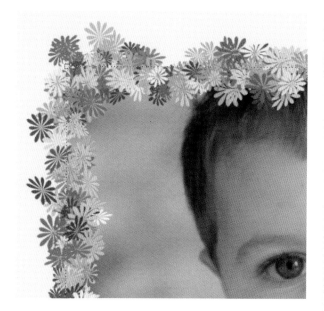

❹ Create a new Layer above. Check the size of the brush from the *Options Bar* (we chose 100 px). Moving your cursor over the image will reveal the size of the brush. Draw a flowery border around and overlapping the photo. You will see that this *Special Effect Brush* used the Foreground and Background colours to create a complex floral design.

ALTERNATIVES

The square format does not mean you have to use a square design. This floral border is used to frame a photo that has been trimmed to a circle using the *Elliptical Marquee* tool. Care should be taken to avoid shadow when you shoot the photo of the flowers so that they can more easily be cut out from the background.

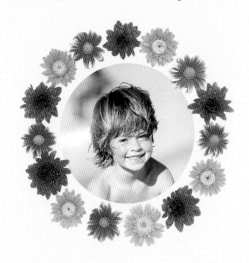

16
embossing powder

Embossing powder is used to give a glossy raised surface to a print. Heat is applied to melt the powder, which adheres to the printed area of the print.

Special embossing paper is thick so that it can withstand heat and treated so that the ink doesn't dry instantly. However, you should apply the powder immediately after printing. A hot air gun like those used for furniture paint stripping should be used, as a hair dryer will not reach the required temperature.

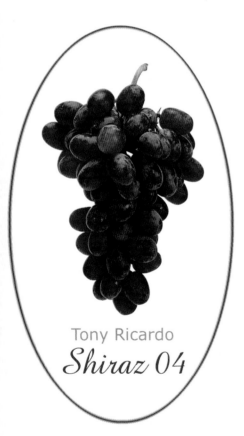

Tony Ricardo
Shiraz 04

I Open a new document in Elements, 8.5 x 11in (21.5 x 28cm) or A4 size, and paste in your photo. As the embossing powder adheres to the wet ink, images with rich, deep colours with plenty of ink work best.

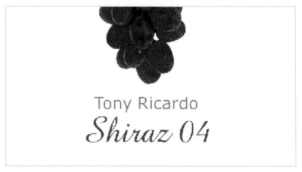

Tony Ricardo
Shiraz 04

2 This image has already been cut out, so it is only necessary to add the text and border. Add two new layers and type in the text. We used the font Amazone for the main title and Verdana for the subtitle. You will have to use a font available on your computer.

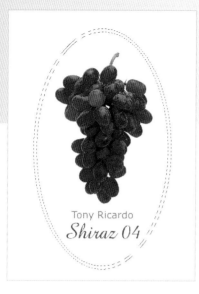

3 On a new Layer, use the *Elliptical Marquee* tool to define an oval shape surrounding both the photo and text. From the *Select* menu, choose *Modify/Border*. The size will depend on the size of your image. Somewhere between 8 and 19 px should be fine.

4 Use the *Paint Bucket* tool to fill the border with a suitable colour. We chose a maroon to match the grapes (R 151, G 27, B 35).

ALTERNATIVES

There are many subjects suitable for embossing. A naturally shiny object such as a car works well with an embossed finish. It does need to be cut out from the background.

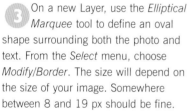

printing and applying the decal

Follow the embossing paper printing instructions supplied with the paper. They are likely to be similar to these.

❶ The paper should be handled only from the edges and away from the image area. Make sure the paper is placed in the printer tray correctly and print with high quality setting.

❷ Sprinkle a small amount of embossing powder over the image. Swirl the sheet around to ensure coverage and tap off the excess onto a spare sheet of paper (it can be reused). You can repeat this if areas of the image do not look sufficiently covered.

❸ Use a dry artist's brush to remove any excess powder sticking to the unprinted areas, taking care not to touch the image area.

❹ Using a heat gun or hot air paint stripper, apply heat to the powdered area. It will begin to melt and go clear, leaving a high-gloss raised surface.

17
adhesive labels

A jar or bottle label is always a popular project. In this example, we have used an image of a young girl to illustrate the naturalness and goodness of the tea.

The self-assured pose of the child helped to suggest the visual approach and title for the label of this home-made drink. Projects like this are also ideal for jams, chutneys, or just about any home-made recipe.

Miss Emily's
VERY FINE
Peppermint Cordial

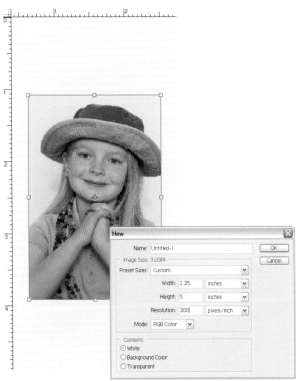

Open a new document in Elements, 2.35 x 5in (6cm x 13cm), and paste in your photo. At this stage, there is no need to rescale the image, as that will be done later. Use the *Paint Bucket* tool to fill the page with a turquoise blue. We used R 195, G 240, B 246.

Miss Emily's
VERY FINE
Peppermint Cordial

2 On four new layers, add the text. The typography is important to support the rather superior style. We have used fonts from the Caslon family. The main title is set in italic with special swash initial caps.

Miss Emily's

3 When you have positioned the four lines of text, they will occupy the bottom third of the page. The remainder will be used for the photo. Select *Frame 13* from the *Custom Shape* tool options. On a new Layer above, define the shape that will surround the photo. It will assume the current Foreground colour. We chose R 147, G 202, B 210.

ALTERNATIVES

Instead of using an opaque adhesive label, you could use a clear permanent decal (*see page 100*). Using one of these, it's possible to remove the background colour and replace it with a thin border so that the coloured contents of the bottle shows through.

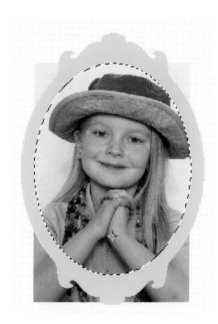

4 Use the *Transform* handles to rescale and position the photo so that it appears within the frame. Reselect the frame Layer. Using the *Magic Wand*, select the area inside the frame and then choose *Inverse* from the *Select* menu. Reselect the photo Layer. With the selection still active, hit the *Delete* key to remove the unwanted area of the image.

screen projects

You don't need to be a Web design wizard to create Web photo albums, Web galleries, slideshows and screen savers, as well as being able to email photos to any location. For these projects, we need to think pixels, not inches. If you are unfamiliar with creating pages for the Web, we recommend that you read these project pages sequentially, as each builds on the skills acquired in the previous one. The websites created for this section can be viewed at the web-linked website (www.prdpuk.web-linked.com), and the source files can be downloaded.

CHAPTER CONTENTS

viewers, players and browsers

The Web browser is a sort of picture frame in which we view webpages. That frame includes a range of buttons and menus which can be customized to work best for you. By far the most popular browser, which is built into Windows XP, is MS Internet Explorer. Explorer was also popular on the Mac, but it has been discontinued since Apple introduced its own browser, called Safari.

To enable Web browsers to display video, sound and animation, there is an additional built-in viewer. In Windows, this is Windows Media Player; on the Mac, it is the QuickTime viewer. In addition to the Web browser, there are other viewers that are necessary to view certain types of media. The most popular of these is the Flash Player. This comes preinstalled in all recent browsers. Another viewer is Real Player, although this is not usually preinstalled in the browser, and is less popular than it once was. All these players are also used as standalone applications outside the Web browser. In other words, you can play music, video or animation from files on your own computer rather than from the internet.

You are likely to be prompted to update these browsers and players from time to time. If you do update them, you will not receive annoying messages 'To view this page you must update…' and you will able to view ever-more sophisticated multimedia entertainment.

In the world of the printed image, an inch is an inch. If you create a Letter-sized document and print it on Letter-sized paper, you will get what you expect. The computer's monitor screen is altogether different. The average size is 17in, but it can be as small as 12in or as large as 22in. Add to this mix the variable resolution of the screen and you begin to see the problem. (Resolution is the number of individual pixels that make up the computer screen image. On a typical 17in screen, it is 1024 pixels across and 768 down.)

Do you know what size your monitor screen is? Well, don't worry – your computer doesn't know either. The computer knows only about resolution. This is still the case even with a notebook computer, where the screen and computer are combined.

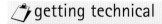

getting technical

Screen resolution

On a Windows XP computer, right-click anywhere on the desktop and select *Properties*, and you can then check your screen resolution settings by selecting the *Settings* tab. In this example, the resolution has been set slightly higher than the average for a 17-in screen. How you set your resolution is partly a matter of personal preference. However, if your screen resolution is set too high, you may see some screen flicker. Use the *Advance* tab and then select *Monitor* to see the screen refresh rate options. They should always be higher than 75 Hertz. Always ensure that the *Colour Quality* is set to *Highest* (it usually is).

INTRODUCING WEB BROWSERS

MENU BAR

ADDRESS BAR

WEB PAGE VIEWING AREA

STATUS BAR

STANDARD BUTTON BAR

LINKS TOOLBAR

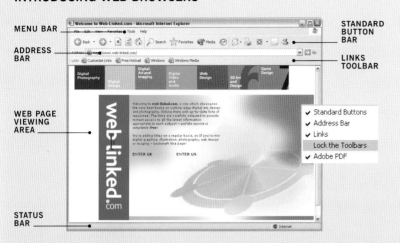

▲ This is an Internet Explorer browser window showing our own web-linked site, from where you can download some of the project files. Right-clicking in the top bar area brings up a dialog box that lets you select which menu bars you want displayed. Make sure that *Lock the Toolbars* is not ticked, otherwise you will not be able to drag the items to a new location.

▲ Safari is supplied with all new Mac OS X computers. It is different in style from Internet Explorer, but is similar in terms of functionality.

▲ In addition to the Web browser, these are the three main media players – from left to right, Windows Media Player, Flash Player and QuickTime. When you are viewing webpages, the player content may be integrated into the browser (like the Flash animation). These screen shots show the players in their standalone guise. Windows Media Player is the default player for Windows XP, although it does work on Macs. It will play most films, music and sounds. The Flash Player will play only Flash films/animations. The QuickTime Player is the default on the Mac, although it is also used quite extensively on Windows XP. It too is used to read movie, image and sound files. Many applications can be used to create screen-based projects that can be played by these players.

▲ Real Player, unlike the other players, relies on a specialist content provider who charges for access to material, and for that reason it is generally used more by professionals or large corporations.

preparing images for the Web

Photos displayed on the Web need to be made as small as possible (in terms of the size of the file) so that they are quicker to download and view on screen. However, reducing the file size means taking information out of the photograph, thereby sacrificing quality. The answer is to obtain an optimum balance between file size and image quality – hence preparing images for the Web is known as 'optimizing'.

One big advantage when viewing images on screen is that a resolution of 72ppi (pixels per inch) is perfectly adequate – rather than the 200 or 300ppi that you need to make good-quality prints. That makes images to be viewed on screen smaller, in terms of file size, straight off.

As well as thinking in pixels, you have to think in KB (kilobytes). If you think of KB like the weight of this book, for example, the intention of

optimization is to make it lighter without changing its size or appearance. And Photoshop Elements, as well as most other image-editing software, has plenty of tricks up its sleeve to help you do that (*see pages 114–117*).

Before you begin the optimization process, you may need to rescale your photo – in other words, change its dimensions. Follow the steps on page 113 to do this.

see pages 114–117; Follow the steps on page 113 to do this.

know your equipment

CAMERA QUALITY OPTIONS

If you take photos with the intention of using them for on-screen/Web projects, it may seem expedient to use the lower quality settings on your camera. This is a mistake; lower quality will usually mean that the images are more compressed. The image sizes will almost certainly have to be changed for screen use and the photograph saved again and re-compressed in JPEG format. This means that an unacceptable reduction in image quality is likely.

jargon buster
MAIN WEB MEDIA FILE FORMATS

Used for	File Extension
Photographs	.JPG/JPEG (either extension can be used)
Photographs	.PNG-24
Graphics	.GIF
Graphics	.PNG-8
Animation, sound and video	.SWF (Flash)
Video, sound and stills	.WMV (Windows Media Player)
Video, sound and stills	.MOV (QuickTime)
Creating webpages	.HTM/.HTML

After you've optimized your images, there are a number of formats in which you can save your images. The table above lists the most common formats for a variety of file types. Of all of them, JPEG and GIF are by far the most common.

RESIZING AN IMAGE

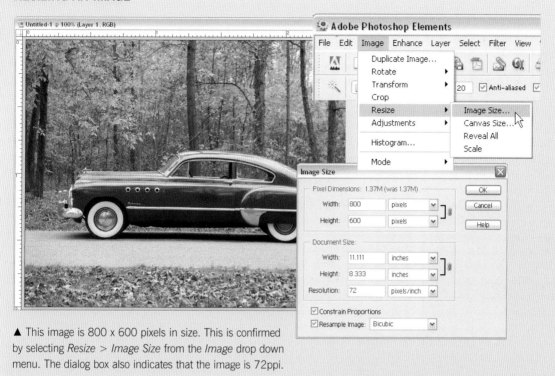

▲ This image is 800 x 600 pixels in size. This is confirmed by selecting *Resize > Image Size* from the *Image* drop down menu. The dialog box also indicates that the image is 72ppi.

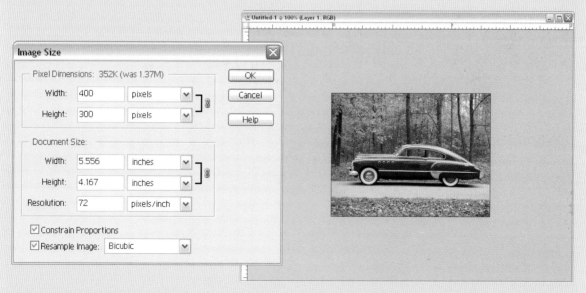

▲ To resize the image, return to the *Image Resize* palette and alter *Width* to between 400 and 600 pixels. Ensure that the *Constrain Proportions* option is checked, and the *Height* will automatically change as well. The *Resample Image* option should also be checked to enforce the change. The car photo is now reduced to the new size.

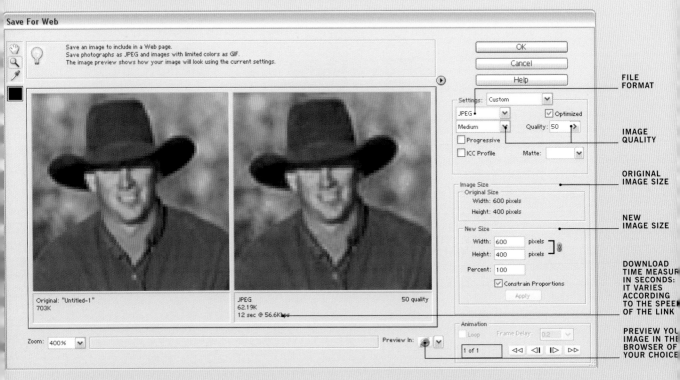

▲ After you've changed the image dimensions, select *Save for Web* under the *File* menu. This dialog box provides you with everything you need to optimize an image for the Web. Here we've optimized a photo using the JPEG format. This is the most popular option, particularly for photos, as it has a wide range of quality settings. Here the preview, zoomed to 400%, shows minimal loss at a *Quality* level set to *Medium 50*. The file size has been dramatically reduced to 62KB from 703KB, which gives an average download time of 12sec with a 56K modem. Experiment with the *Quality* slider until you reach an acceptable balance between image quality and image size. The *Progressive* box, if ticked, allows the image to display a bit at a time.

◀ PNG-24 format is less popular because it doesn't have variable quality options. This means that the file sizes are inevitably larger, like this one at 465KB. PNG-24, like JPEG, does not need to reduce the number of colours in the original. They can both use more than 16 million different colours.

▲ GIF is another popular format. It is used mainly for Web graphics (as opposed to photographs) because the colours in the original image are reduced to a maximum of 256. This results in blockiness, especially when the available colours are reduced to just 32, as shown here. As the Elements' tip box says at the top of the screen, *Save photographs as JPEG and images with limited colors as GIF*.

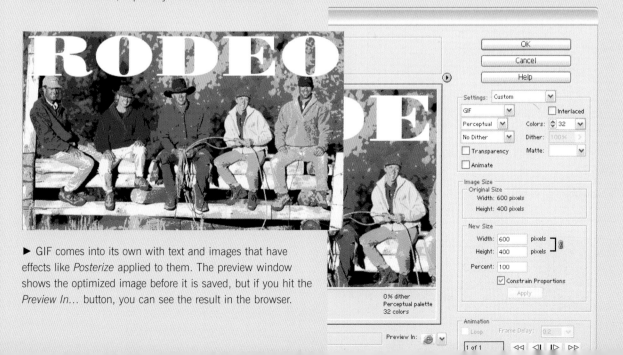

► GIF comes into its own with text and images that have effects like *Posterize* applied to them. The preview window shows the optimized image before it is saved, but if you hit the *Preview In…* button, you can see the result in the browser.

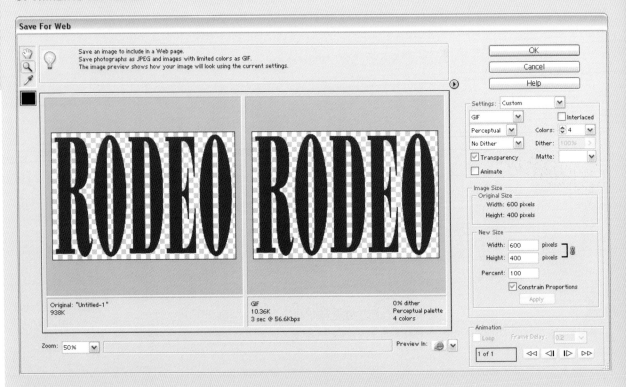

▲ GIF can also be saved with a transparent background, enabling an image in the background to show through. Here the number of colours has been reduced to just 4, enabling the file size to be reduced to 10KB. The ability to support transparent background is also true of PNG.

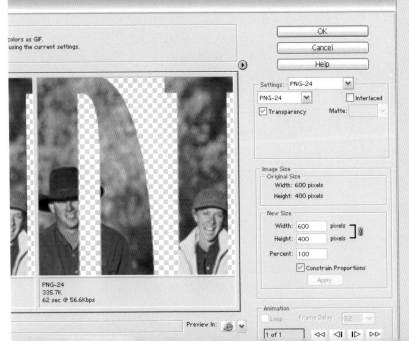

◄ Although PNG-24 creates files that are larger than JPEG, it does have one significant advantage – it enables background transparency in a photographic quality image (remember that it uses 16 million colours).

▲ WMV is a format that is used when you create a Photo Story using Microsoft Plus Digital Media Edition. This application generates a sophisticated slideshow without the user having any previous skills in this area. There are two quality options when you save the file: High and Medium.

▲ WMV is also the format used to output a film created using Microsoft MovieMaker. The application is used primarily for creating films on your computer, but can also be used very effectively to display still images.

▲ On the Mac OS X computer, iMovie is the popular alternative to MS MovieMaker. Its files are saved in QuickTime format. In addition, iPhoto is used to manage, enhance and store digital photographs.

Save an image to include in a Web page.
Save photographs as JPEG and images with limited colors as GIF.
The image preview shows how your image will look using the current settings.

18
email your photos

Sending your digital photos by email is fine as long as you abide by email etiquette. The recipient normally has no way of stopping an email downloading to their computer, so you must consider whether or not to send an unsolicited email, particularly if it has an attachment.

Even when you are sending something to a friend or relative, it is courteous to email them ahead to say that you are going to send an attachment. Make sure the attached image has been optimized to the smallest possible file size. Many people do not have a broadband connection and it is very irritating to see your email software endlessly awaiting an incoming message. Always type a descriptive phrase in the message subject box. If you do decide to send an unsolicited email and it is to multiple locations (a Christmas card, for example), use the BCC (Blind Carbon Copies) option to hide other recipients' email addresses.

EMAIL PHOTO MESSAGE

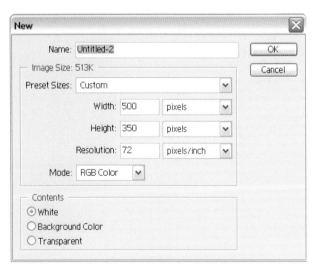

 Open a new document 500 x 350 pixels with *Resolution* set to 72 pixels/inch.

2 Paste in the photo and use the *Transform* handles rescale to fit the area required.

3 Select the Background and use the *Paint Bucket* tool fill with a colour of your choice. Here, we have matched the rim of Jim's cap.

4 On a new layer above the others, select the *Horizontal Type* tool and type in the headline. We have used a funky font called Pompeia. Repeat this process, this time with the main message; you should use a smaller font size than that used for the headline.

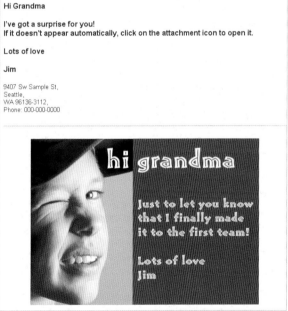

5 From the *File* menu, select *Save for Web* and choose *JPEG*. We left the settings as default except for *Quality*. A level of 84 was necessary to avoid degrading the text, but the resulting file size was still below 72KB.

6 Now the JPEG file has been Optimized, it is ready to attach to an email message; here Jim is emailing his grandma with some special news that is contained in the image created in steps 1 to 5. He is using MS Outlook Express and has personalized the background selecting *Maize* from the *Format > Apply Stationery* menu.

19
an online photo gallery

Using Elements to create a Web gallery that can be shared online or put onto CD is easy. Simply follow the steps described over the next few pages, and within minutes you could be sharing your latest holiday photos with relatives on the other side of the world.

Now that you've discovered how to optimize images for the web, the next stage is to create an online photo gallery that anyone can view on the Internet. You could also copy the gallery to a CD-ROM and give it to a friend or family member to enjoy. The number of images you can put in the gallery is almost limitless, and it's a perfect way to show and share your latest holiday, wedding or christening photos.

tip

Naming your files

During the course of this project, you will be asked to name the photo files as you save them. Remember to give the photos descriptive names, as these will be how the photos are labelled when they appear in the gallery. However, there are strict limitations for pages that are to be transferred to a Web server: no commas can be used and no spaces between words – an underscore_ must be used instead.

Create a folder called 'Web Photo Gallery'. Within that folder, create another folder called 'Originals'. Drag the images that you plan to use into this folder. Open each image in Photoshop Elements and select *Save for Web* from the *File* menu. Choose *JPEG* as the file type and select a *Quality* value that is suited to your image. Here, it is 40. In the *New Size* option, type in 500 (pixels) as the *Width* value. Ensure that *Constrain Proportions* is checked. Then hit the *Apply* button. If the photo is portrait format, change the *Height* to 500 (pixels) instead.

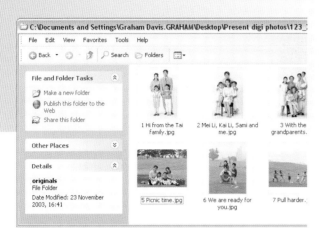

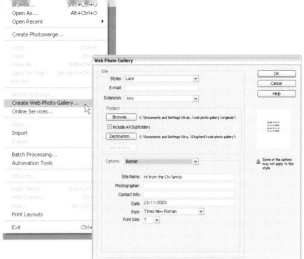

2 Click *OK* at the end of step 1 and name each file, using a short descriptive phrase of no more than 30 letters and spaces. With the exception of a comma or hyphen, do not use characters other than letters or numbers. The file name will be used as the title for each photo in the gallery. To ensure that the photos display in the desired order, add a number at the beginning of each file name.

3 Select *Web Photo Gallery* from the *File* menu. The resulting palette has a range of options. Select your preferred option from *Styles*. We chose *Lace*. Click the *Browse* button and select *Originals*, the folder that contains your photos. Click the *Destination* button and select the *Web Photo Gallery* folder. From the *Options* menu, select *Banner* and type in the site name. All other settings can be left at the default values. Click *OK*. Elements takes 20–30 seconds to create the Web gallery and launch it in the browser.

4 The home page has a series of thumbnail images that, when clicked, fire up the relevant page with the full-size (500 pixel) image. Navigational arrows allow you to toggle through the images without returning to the home page.

5 The folder that you created and called Originals has now been joined by three other folders and two files called 'index' and 'UserSelections'. These are automatically created by Elements. Double-clicking on the index file will fire up the home page in the browser.

20
using an online gallery service

Using an online image gallery is the easiest way to get your photos onto the Internet. Most of the camera manufacturers offer this facility.

Using an online image gallery is usually free, so you can expect to be offered additional paid-for services as well. It is best to prepare the images that you wish to use in advance before 'posting' them to the site – for example, remove red-eye, improve contrast and so on *(see pages 28–37)*. Most online galleries will have an image file size or maximum image dimension limitation.

Kodak Ofoto (found at www.ofoto.com) is an online photo gallery that includes a free assemble and upload utility called OfotoNow. This can be downloaded and installed on your own computer. Your photos can be uploaded to an online Ofoto album and emails with the relevant link sent to you. Your photos can also be saved as a screensaver, but only on the user's computer – it cannot be exported. Ofoto is closely associated with Kodak Easyshare.

Sony Imagestation (found at www.imagestation.com) is another online gallery. This is an online photo album with a variety of themes and backgrounds that can be selected to enhance your photos. Your images can very easily be uploaded by drag-and-drop and simple captions added.

The advantage of these systems is primarily their ease of use, particularly in uploading photos from your computer to the internet. They are also quick. In a few minutes, your photos are available for your relatives and friends to see. Both require registration before you can start uploading. When you see the photos in the browser, you know that you are looking at them on the website and not on your own computer.

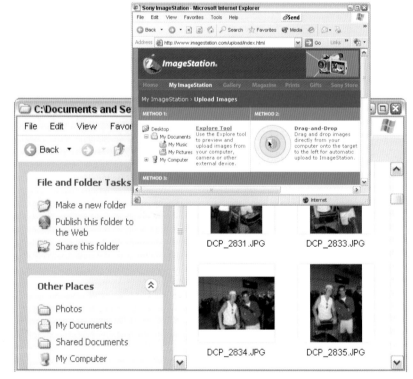

Connect to the Imagestation website. You will be prompted for your Member Name and Password. From your own computer, select the folder that contains the photos that you wish to upload. Simply drag them onto the blue target on the Imagestation browser window and then click the *Upload* button. (When you drag and drop onto the target you are not moving the original image, just a copy of it).

SONY IMAGESTATION

2 Wait for the upload to complete. There will be an Upload confirmation. Next, click the *Go to Storage Bin* button, where you will see the images. Click the *Create New Album* button. You will be prompted to fill in some details. Click *Continue*. You will then be prompted to choose an Album Style.

3 The style applied here is *Travel > Mass Transit*. Next, click *Enter* to view your album.

4 You can edit each image online and apply enhancements using the *Effects*, *Textures*, *Templates* or *Edges* buttons.

KODAK OFOTO

① Click the *Ofoto* icon to launch the application and select the *Get Photos* button. Click the tick box to select the photos that you wish to use. You have the option to rename photos. This alters the file name on your computer, so it is sensible to have a duplicate backup of the folder that contains the photos before you start.

② Click the *Upload* button and insert your email address and password.

③ You will be prompted to fill in details for your new album. When you have completed these, click the *Finish* button. The upload process will begin automatically.

④ When the uploading is complete, your photos will appear in the browser window. On the right-hand side, various options are displayed that enable you to add titles to each photo as well as other enhancements.

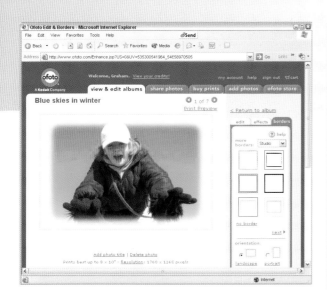

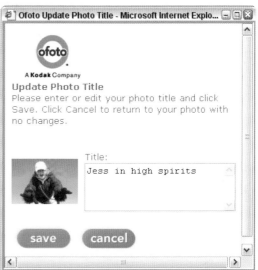

5 Choose a border or other effect. Here, the softened edge (vignette) was selected from the *Borders > Studio* sub-menu. This is immediately applied to your photo. You will have to apply this effect individually to each photo, using the arrow buttons to move from image to image.

6 Next, select each photo in turn and click *Add Photo Title*. Add your preferred title in the pop-up window.

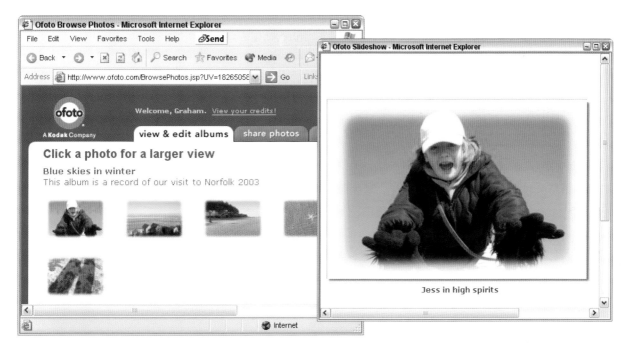

7 Your online album is now complete. Thumbnails of your photos appear in a new window. Click on the *Slideshow* link, and they will appear full-size.

8 Finally, click on the *Share Photos* tab if you wish family or friends to see your new online album. You will be prompted to fill in their email addresses along with a message.

21
a home page

There are two ways to create websites. One method is to learn how to master complex Web-authoring software using FTP to transfer them to a Web server. Sounds scary!

The other, simpler, method is to use an online page builder like Yahoo! GeoCities. This offers Page Wizards to create simple webpages based on templates. To make the process as painless as possible, a little preparation will help. In step 7, for example, you will be prompted to type in your text. This will be easier if you have written it first so that you can simply paste it in. Images should be resized and optimized, or you will quickly run out of the free Web space that Yahoo! GeoCities offers.

The Wilson Family

Hi my name is Grace Wilson, I am 32 years old and married to Bob who is 36. Our three children are Will (9), Tom (7) and Tania (5), and we must not forget our dog called Buster. We live just outside Seattle in a lovely old house with a large garden. The boys love fishing and all things watery, we have a small sailboat. Tania is a home bird but she has lots of friends, her great passion is painting and drawing.
As a family we are quite health conscious but not obsessive, Bob runs twice a week and we all swim regularly. We like to travel and we have visited Europe and Australia where I have a cousin.
Our home is decorated in traditional style but we tend to buy things that we like rather than always go for the period look. The garden is a wilderness waiting to be tamed, fortunately Bob's dad Ted is a knowledgeable and

Tania is all mumsy!

My Favorite Links:

Yahoo!

Yahoo! Games

Yahoo! Photos

Yahoo! Greetings

My Info:

Name: Grace Wilson
Email: wilsonfamily1911

Not Online right now

Hi my name is Grace Wilson, I am 32 years old and married to Bob who is 36. Our three children are Will (9), Tom (7) and Tania (5), and we must not forget our dog called Buster. We live just outside Seattle in a lovely old house with a large garden. The boys love fishing and all things watery, we have a small sailboat. Tania is a home bird but she has lots of friends, her great passion is painting and drawing.

As a family we are quite health conscious but not obsessive, Bob runs twice a week and we all swim regularly. We like to travel and we have visited Europe and Australia where I have a cousin.

Our home is decorated in traditional style but we tend to buy things that we like rather than always go for the period look. The garden is a wilderness waiting to be tamed, fortunately Bob's dad Ted is a knowledgeable and willing helper and we are hoping to finish the major paving and planting later this year.

This is our first web page and so I hope it works ok
Grace Wilson

→ tip

The Yahoo! ID

When you apply for a Yahoo! ID, this becomes your login name and part of your website URL:
(http://www.geocities.com/name_placeholder).
The demonstrations on this and the following pages have 'name_placeholder' wherever the name that you choose will appear.

1 To save time later, when you are online, first type your text into a word processor and then choose a portrait-format photo to accompany it. Resize the photo so that it is 400 pixels deep and optimize it (*see page 113–117*).

2 Connect to the Internet and then to the Yahoo! GeoCities sign-up page. You must complete a form with your details before proceeding. As this service is free, banner ads may be included on your page. You can, however, select the most appropriate topics.

3 From *Build My Web Site*, select *Yahoo! Page Wizards*.

Welcome, name_placeholder

http://www.geocities.com/name_placeholder

geocities.com/name_placeholder

GeoCities Free

<u>Home</u> > **PageWizards**

Yahoo! PageWizards

PageWizards are a fun and fast way to make cool web pages. Just answer a few questions and build a professional-looking web page in minutes.

Quick Start - Eight designs to choose from and just four easy steps.

Fun D'Mental

Techie

Night Vision

Disk Drive

Featured Themes

<u>Photo Page</u>

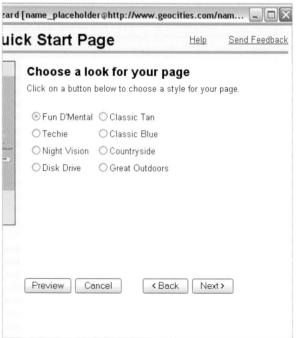

Include a message and up to eight photos with captions. Choose from eight designs.

4 From the *Eight Quick Start* designs, select *FunD'Mental*.

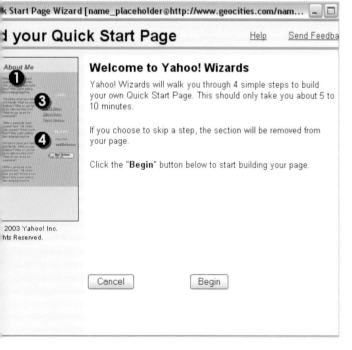

5 The Welcome screen introduces the four steps of the process. Click the *Begin* button.

6 If you want to change the design, select an alternative and click the *Preview* button. Then click the *Next* button.

7 Enter the title and then either type in the text or paste in the text that you prepared earlier. Click the *Next* button.

8 Click the *Upload new image* button so that you can select the photo to accompany the text.

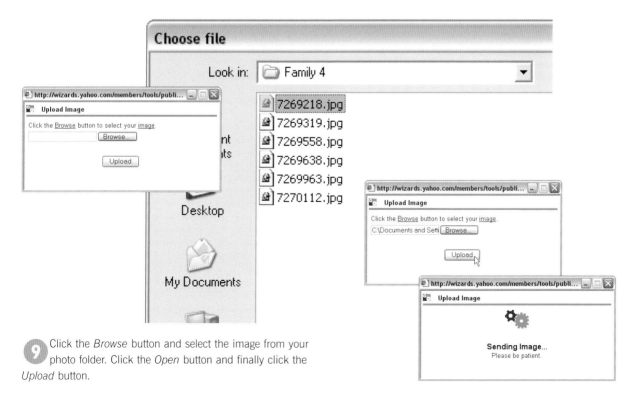

9 Click the *Browse* button and select the image from your photo folder. Click the *Open* button and finally click the *Upload* button.

►►

The resulting Links page allows you to add some personal links. For the time being, we will leave the default settings. Click the *Next* button.

Add your personal information. If you want to use the message service, leave the *I'm Online* button checked. Click the *Next* button.

Use 'index' as the name for your page. This is important: the home page on all websites must always be named 'index'. You can give any additional pages a descriptive name. Remember to use an underscore instead of a space between words. Click the *Next* button.

The page wizard has now been completed. Your Yahoo ID – the name that you used to sign on to the Yahoo! GeoCities service – will appear instead of 'name_placeholder' in your Web address. Click the *Done* button.

Welcome, name_placeholder **http://www.**
geocities.com/name_placeholder

View the Page

You can bookmark this URL or send it to friends.

http://www.geocities.com/name_placeholder/The_Wilson_Family.html

Make Changes

Change the information you entered

The steps will be filled in with the information you just provided, so all you need to do is make your changes.

Edit with PageWizards

14 You can now either view your page or make changes to it using the *Edit with PageWizards* button. The next project shows how you can Enhance your page with another application called PageBuilder.

→ tip

The Yahoo! GeoCities free service

At the time of writing, the steps shown on this page are correct. If Yahoo! GeoCities make any alterations or improvements, a revised page will be published on our own web-linked.com website, which all purchasers of this book have access to (*see page 166*).

EDITING WITH PAGE WIZARD

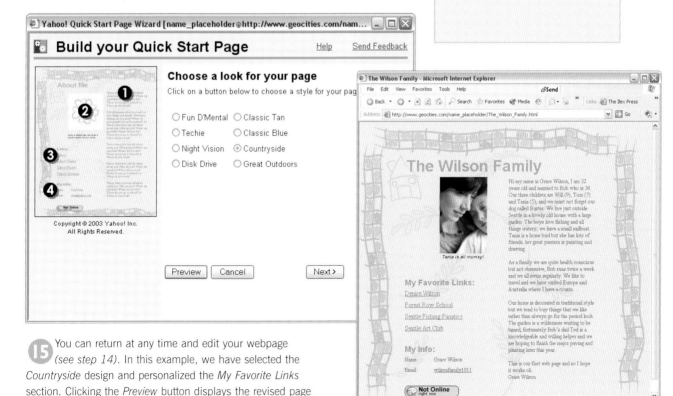

15 You can return at any time and edit your webpage (*see step 14*). In this example, we have selected the *Countryside* design and personalized the *My Favorite Links* section. Clicking the *Preview* button displays the revised page in the browser.

22

a family website

The next stage is to design a website. This is made simple by using an online tool called Yahoo! PageBuilder.

PageBuilder allows you to design pages using simple, intuitive tools. You can start with one of the templates provided and then adapt and personalize it if you wish, adding new photos and text. To use this service, you need to be connected to the Internet. To obtain a Yahoo!ID, see the box on page 127.

Start the project by connecting to the Internet. Open the Yahoo! Geocities webpage and sign in (this may not be necessary; the website will probably recognize you if you have signed in previously). Click on the *Countryside* design using the *Quick Start* template option. A small browser window will open. This is the 'engine' that drives PageBuilder. It must not be closed until you have finished working on your site.

→ **tip**

First, 'optimize' your photos

Although PageBuilder will allow you to resize your photos when you are designing your pages, it is best to prepare them for Web use first. A convenient size is 400 pixels wide or deep, whichever is the longest. Each image should then be optimized using Photoshop Elements or a similar image-editing application (*see pages 114–117*).

2 The resulting page will show the 'Countryside' image as a background to the page, along with blue rectangles containing text and one with an image (a flower graphic). Double-click on the graphic and the *Select Picture* palette appears. The *Picture List* show the default images. As we want to add our own image, hit the *Upload* button.

3 The *Upload Files* window appears with five *Browse* buttons. Click on a *Browse* button. From the *Choose File* window, select the folder containing the images that you want to use for your webpages. Choose one of these and click *Open*. Repeat the process until all five *Upload* options contain an image, then click the *Upload* button. Another window will appear to confirm the successful upload.

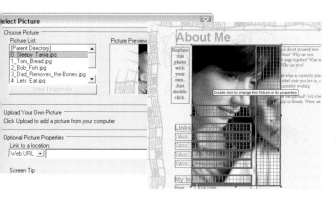

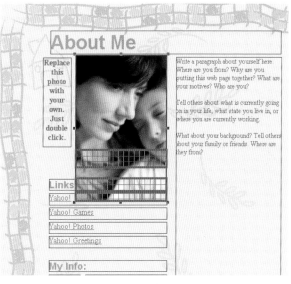

4 Double-click on the flower graphic again. From the *Picture List* menu, double-click on the *Parent Directory* and again on *User Files*. The files that you have just uploaded will appear on the list. Select the photo to be used on the home page and hit the *OK* button. Your own image will now replace the flower graphic. If you have selected the wrong image, simply double-click on it and select another. As the new photo is bigger than the flower graphic, it overlaps some of the text. This is indicated by the red crosshatching.

5 Using the corner handle, make the image fit within the column. Don't worry that some of the overlap persists; we will return to that later.

►▌

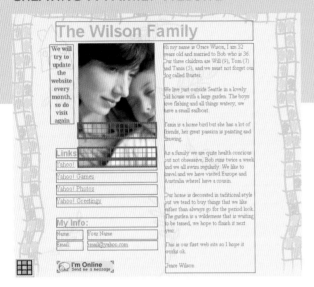

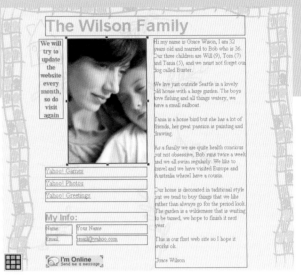

6 We now turn our attention to the text. For technical reasons, it is not possible to paste text into the PageBuilder text blocks, so it has to be typed in. Start with the title, the update message and the main text.

7 Click on the photo and drag it off to the right. Delete the text blocks that were overlapped by it, then move it back to the previous position. The red crosshatching will have disappeared.

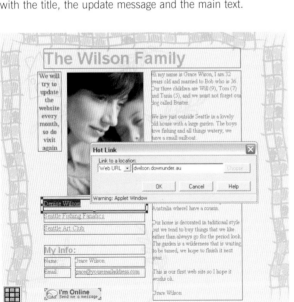

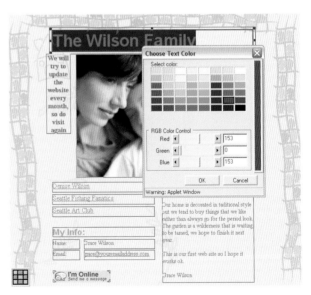

8 Select each of the remaining three website links (below the photo) and type in your alternatives. With text selected, click on the *Links* button. From the resulting *Hot Links* palette, with the Web URL option selected, type in a Web address to match the name. If you wish to add your own email address to *My Info use*, follow the same process but make sure *E-Mail* is selected and not *Web URL*.

9 With the title selected, click on the *Choose Text Colour* button and select a new colour. You can change the colour of all text blocks if you wish.

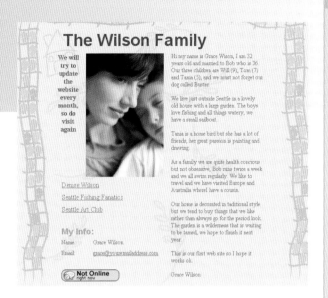

The Wilson Family

We will try to update the website every month, so do visit again

Hi my name is Grace Wilson, I am 32 years old and married to Bob who is 36. Our three children are Will (9), Tom (7) and Tania (5), and we must not forget our dog called Buster.

We live just outside Seattle in a lovely old house with a large garden. The boys love fishing and all things watery, we have a small sailboat.

Tania is a home bird but she has a lot of friends, her great passion is painting and drawing.

As a family we are quite health concious but not obsessive, Bob runs twice a week and we all swim regularly. We like to travel and we have visited Europe and Australia where I have a cousin.

Denise Wilson

Seattle Fishing Fanatics

Seattle Art Club

My Info:

Name: Grace Wilson

Email: grace@youremailaddress.com

Our home is decorated in traditional style but we tend to buy things that we like rather than always go for the period look. The garden is a wilderness that is waiting to be tamed, we hope to finish it next year.

This is our first web site so I hope it works ok.

Grace Wilson

Not Online right now

10 You have now finished adapting the page. It is time to see what it looks like in the browser. Click the *Preview* button and the page will appear.

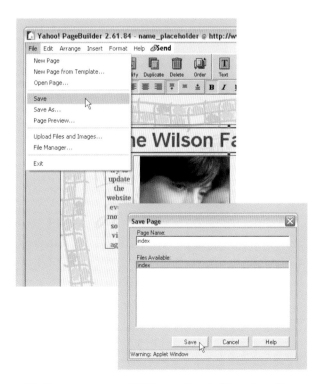

11 If you are happy with the result, select *Save from the File* menu. As this is the website's home page, it must be called 'index' – you don't have any choice!

adding another page to your website

❶ To add another page to your website, repeat step 1 from page 136. A new page will appear using the same *Countryside* background. As we want this page to contain only photos and captions, delete all the other text blocks. Leave just the flower graphic, caption and the title, which we have changed to 'Dad's Cooking'.

❷ Double-click on the flower graphic. From the *Select Picture* palette, choose the first image (as in step 4). Resize the image to a convenient size and type in a real caption below it. Click the *Pictures* button. Select the next image from the *User Files* menu and resize this also. Continue adding and resizing photos until complete. Now attention is turned to the remaining captions. The easiest way is to click on the existing caption and then, from the *Edit* menu, select *Duplicate*. Drag the duplicate caption to the new position and type over with the correct text.

❸ The second page is now complete, except that a link is needed back to the home page. Clicking the *Text* button creates a new empty text block. Use the handles to make this a convenient size and then drag it to a new location at the top of the page. Type in 'Home Page' and, with the text selected, click on the *Links* button. Select *My Page* from the *Link to a Location* drop-down menu and select *index.html*.

❹ From the *File* menu, select *Save* and name the page. Remember to use an underscore (_) instead of a space between words.

❺ Click on the *Open* button and select index (the home page). We now need to add a link from here to the Dad's Cooking page that we have just created. Repeat step 3 and save the page. Next you will see a window stating *Save and Publish is complete*. These pages can now be viewed by anyone on the Internet.

23

a cyberscrapbook

You may have noticed that the background image used in the previous two projects is repeated when the browser window is at maximum size.

This feature is called 'Tiling' (*see box on page 143*). For this project, we are going to create our own background and navigation buttons rather than use those supplied by PageBuilder. The Web graphics and photos are prepared using Photoshop Elements. These are then uploaded and the webpages created using Yahoo! Geocities PageBuilder.

A day at the Zoo

There are so many different types of animal at the zoo. The antelope is very nervous except when he can't see you; the hippo is so relaxed he doesn't mind having a little bird on his head.

CREATING THE INTERFACE

1 Open a new document in Elements, 1000 x 630 pixels. This will be used to assemble the various items to be used on the website. On a new layer, use the *Lasso* tool from the *Tools* palette to draw a freehand line (simulating a torn edge) roughly 100 pixels from the left side. Continue it along the bottom, side and top until you join up with the start point. Release the mouse and you will have completed the shape.

Use the *Paint Bucket* tool to fill the shape with colour. We used R 71, G 207, B 180. Using the *Rectangular Marquee* tool, define a rectangle, the left side of which is aligned with 680 pixels on the Ruler. Fill this with same colour. This will be used as a background image on the webpage. As it will repeat, the bottom of the image needs to join up with the top. A quick way of ensuring this is to use the *Rectangular Marquee* tool to define a small rectangle about 20 pixels deep. Align it to the right of an imagined vertical line at the 100 pixel point. (Elements does not have Guides that can be pulled out to align images.) We have zoomed in so it is visible. Now delete the small area of image within the marquee. Repeat this at the bottom of the page.

From the *Layers Style* palette, select the *Soft Edge Drop Shadow*. After it has been applied, double-click the *Layers Styles* icon on the *Layer* palette. Change the *Lighting Angle* to 180°. This causes the shadow to appear horizontally rather the obliquely. If left at the default setting, a gap would be apparent if the background image repeats.

►►

CREATING THE INTERFACE

4 From the *Tools* palette, change the Foreground colour to a darker shade. We chose R 51, G 153, B 128. Click on the *Rectangle* tool flyout menu and select the *Custom Shape* tool. Now choose the *Paw Print* from the *Options Bar*.

Use the cursor to drag out the paw shape. This automatically creates a new layer, Shape 1. From the *More* button on the *Layers* palette, select *Simplify Layer*. This converts it into a normal editable layer.

5 Position the paw-print image. Then duplicate the layer twice to create the other two images. On a new layer beneath each paw layer, use the *Horizontal Type* tool to add the text 'Page 1', 'Page 2' and 'Page 3'. We used 10 point Arial bold in the same colour as the paw graphic.

6 On a new layer type in the title, we used a font called Spumoni at 80 point size. The layers created so far should look like this. If you want to change any of the layer names, you can do so by double-clicking on them.

SAVING IMAGES FOR WEB USE

7 Turn off all the layers except the Green Edge. From the *File* menu, select *Save for Web*. Select *GIF* and change the colours to 16. Leave the other settings as default and click *OK*. We called the file 'green edge background'.

8 To save the buttons for Web use, use the *Rectangular Marquee* tool to make a selection around one. Now select *Edit > Copy Merged*. This copies all layers, so you can paste them into a new document as a combined layer.

9 Select *File > New* and then *OK*. Select *Edit > Paste* and the button image appears. From the *File* menu, select *Save for Web*. Select *GIF* and change the colours to 8. Leave the other settings as default and click *OK*. We called the file 'button_page_1'. Repeat this with the other buttons.

10 Now make a selection around the title and repeat the process described previously. You now have five GIF files that will be used as your website interface. Reducing the number of colours in a GIF file can produce tiny file sizes. The buttons are only 1KB each.

ASSEMBLING THE WEB INTERFACE

11 Connect to the Internet and sign in to Yahoo! Geocities PageBuilder, as described in the previous project. When the PageBuilder page displays, select *FileManager* from the *File* menu.

12 The PageBuilder FileManager shows the pages that you have created and files that you have uploaded, as well as those that PageBuilder supplies to all users. For the moment, it is empty. Select the *Images* tab and hit the *Upload* button. We will begin the process of transferring the GIF files created previously.

13 From the *Upload Files* palette, click the *Browse* button and select a GIF file. Click *Open* (a rather confusing button name, as the file does not open!), and repeat the process until all five files have been selected. When the upload is complete, FileManager displays all the five images. If you need to delete one at any time, tick the relevant *Select* box.

14 Return to the PageBuilder window and select *Basic > Background* from the *Insert* menu. In the *Picture List*, click on the Parent Directory to access your files saved under User Files. Choose the background image. A small preview picture will appear. Click *OK* (not *Upload*, as we have already completed this stage).

ASSEMBLING PAGE CONTENT

The background image now appears on the page. Click the *Picture* button and select *button 1*. Click *OK* and it will appear on your page. Repeat this process with the other two buttons and drag each of them to the correct position.

Repeat the process again with the title. You can reposition the images at any time by simply dragging them. Remember that, with the exception of the background image, no other images (or text) should overlap.

We have finished with PageBuilder for the moment and now return to Elements. Even though individual images have to be saved for Web use, it is often convenient to assemble the elements in one layered file, as we are doing. It enables the designer to balance size, proportion, and colour in a way that would be much more difficult if the elements were all created separately. Paste in the photo of the chimp that will be used on the home page. It is larger than the total page size, so zoom out to a convenient size (probably 25%) and use the *Transform* handles to reduce it to the desired size.

Paste in the photo of our young website author above the chimp layer and resize to overlap the chimp at bottom right. From the *Layer Styles* menu, select *Drop Shadow > Soft Edge*. If the *Lighting Angle* is still 180°, uncheck *Global Light* and change it back to 120° (the default setting). With *Global Light* checked, changing the lighting angle will make all previously applied drop shadows change too. Use the *Rectangular Marquee* tool to make a selection around the two photos. Select *File > New*. Then click *OK* and *Paste* from the *Edit* menu and the image appears.

►►

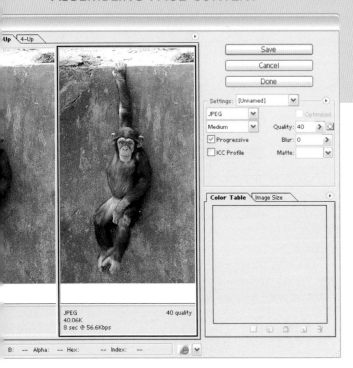

19 From the *File* menu, select *Save for Web*. These photos need to be saved in JPEG. Leave the settings at default except for *Quality*. This can be reduced to 40, resulting (coincidentally) in a file size of just over 40KB. This is large, but not excessively so. Check *Progressive*. This allows the image to display gradually – useful over slow Internet connections.

21 Connect to the Internet and sign in again to Yahoo! Geocities PageBuilder. Your home page should open by default. Repeat the file uploading process described in steps 12–14, this time with the three new JPEG images. Use the *Pictures* button to select the chimp photo to be used on the home page. When it appears, drag it to the correct position.

20 Repeat the process described in the previous three steps for the images to be used on the other two pages. We can now dispense with Elements for the remainder of the project.

22 The home page is now nearly complete. It will be used to form the basis of the other two pages. Make sure you save it first. Then, from the *File* menu, select *Save As* and call it page 2. Repeat the process with page 3. From the *File* menu, select *FileManager*. You will see the three pages if you click on the *Pages* tab.

The final task is to add page links to the buttons and add some text to each page. Return to index, the home page, and click on the *Page 2* button to select it. Click on the *PageBuilder Link* button. From the *Hot Link* palette, select the *My Page* option. Now choose *page 2* and click *OK*. Repeat this process with the *Page 3* button. As we are editing the home page, it does not need a link to itself, so don't create a link for the *Page 1* button.

Click on the *Text* button. Drag the resulting text box to a position under the photo. It can be made wider or deeper to fit the text using the cursor. Select the centred text icon from the *Options Bar* and type in the text. The home page is now complete. After saving this page, open page 2 and add links and text to it. Repeat this process for page 3.

The finished pages can be checked in the browser to see if the links have been added correctly.

→ tip

Tiling the background image

If your computer screen is large enough, you will be able, with your browser screen maximized, to see how the background image repeats itself (tiles). As we made the image 1000 pixels wide, it is unlikely to repeat on the width. However, if your text block was 20 lines instead of just three, a scroll bar would appear on your browser. When you scroll down to the bottom, the effect of tiling would become apparent.

ICC Profile Matte:
Image Size
Original Size
Width: 109 pixels
Height: 117 pixels
New Size

24

an online wedding album

This project uses the same method as the previous one; we use Elements to prepare the images and PageBuilder to assemble the webpages.

The PageBuilder page defaults constrain the page width to 650 pixels and do not allow images to overlap (layered HTML). We have changed the settings for this project to allow both. A text list of links to other pages has been added to each page to enable navigation. The design is contemporary and complements the informality of the photos.

CREATING THE INTERFACE

THE DOILY IMAGE

Scan the paper doily. If it is white, you will need a black background. Select *Image > Adjustments > Invert*. The image is now black on white. If the scan is a bit grey, boost the contrast using *Enhance > Adjust > Brightness*. Use the *Magic Wand* to make a selection outside the doily. Delete this area. Use the *Magic Wand* again on the black area of the doily and delete that. You are left with a white image of what was originally cut out.

Open a new document in Elements, 1000 x 630 pixels. This will be used to assemble the various items to be used on the website. Use the *Paint Bucket* tool to fill the Background with colour. We used R 196, G 181, B 229. Paste the doily image in on a new layer and reduce the *Opacity* to between 45 and 15%. Repeat this process two more times.

CREATING THE INTERFACE

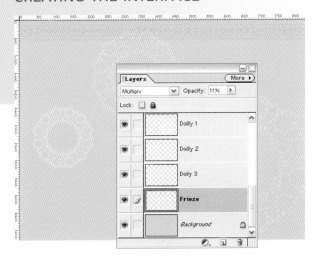

2 On a new layer below the doilies, add the frieze image across the top. Then change the *Layer Blend Mode* to *Multiply* and reduce the *Opacity* to 11%. This allows the background to show through the image.

3 As we want the title to appear on every page, we are making it part of the background image. We have used two fonts: Ribbon (120 point) for 'Our Wedding' and Birch (42 point) for the names.

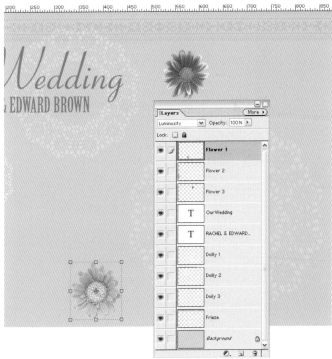

4 The three flower images that we have already cut out (see box below) are pasted into new layers above the others. Rescale them if necessary and position as required.

THE FLOWER IMAGES

The flower images need to be cut out. Use the *Lasso Tool* to define a shape around the flower. Then go to *Select > Inverse > Delete*. Use the *Magic Wand* to select an area and delete that. Carry on until you are left with the awkward areas; use the *Selection Brush* to remove these.

5 Using the *Layers* palette, change the *Layer Blend Mode* of the three flower layers to *Luminosity*. They will now adopt the colour of the layer below. Reduce the *Opacity* as well if necessary.

▶▶

CREATING THE INTERFACE

6 On a new layer above the others, paste in the main image to be used on the home page. Use the *Transform* handles to rescale them. Zoom out to 25% or whatever is necessary to see the extent of the image. The size of this image will be the basis for photos to be used on other pages.

7 Create a new document to allow you to choose which photos you want to go on the website. Open a new document, 1500 x 1200 pixels. Copy the photo used in step 6 and paste it into the top left of the page. Paste in the photos that you intend to use for the first few Web pages. Rescale them and then select *Layers > More > Merge Visible*. Ensure that the Background is turned off before doing so. Using the same background colour as the main document will help if you need to enhance any of the photos.

SAVING IMAGES FOR WEB USE

8 For the moment, return to the main document and turn off the photo so that just the graphics to be used as the background remain visible (as the image in step 5). From the *File* menu, select *Save for Web*. Use the *Hand* tool to drag the area previewed, as shown in the screen shot. This shows all the elements of the image – text, frieze, flower and doily. This is important, as the number of colours must be reduced to the absolute minimum when saving a GIF in order to reduce the file size. Here, we have reduced the number to 12 while retaining acceptable quality. However, the file is still a sizeable 46KB.

SAVING IMAGES FOR WEB USE

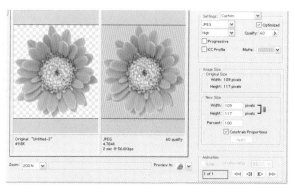

9 Now return to the collection of images described in step 7. Turn the Background off. As the images were merged into one layer in step 7, you have to first make a selection around each one using the *Rectangular Marquee* tool. Start with the flower: select *Copy* from the *Edit* menu and paste it into a new document.

10 Select *File > Save for Web*. Click on the *Eyedropper Color*. Ensure it is the same as the background. Select *JPEG* from the *Matte* drop-down menu. A matte is a tiny fringe of background colour that is added to an image and smoothes out the join between a transparent image and the background colour. Choose *Eyedropper Color*. This adds the background colour to the image preview. Drag the *Quality* slider until the minimum acceptable value is reached; in our case, it was 60. Click *OK*. Repeat with the other flowers and continue with the other photos. As these are squared-up images, you can reset *Matte* to *None*.

UPLOADING AND ASSEMBLING WEBPAGES IN PAGEBUILDER

11 Connect to the Internet and sign in to Yahoo! Geocities PageBuilder, as described in a previous project. When the PageBuilder page displays, select *FileManager* from the *File* menu. With the *Images* tab selected, click the *Upload* button and *Browse* to select all the image files saved above.

12 Return to the main PageBuilder window and select *New* from the *File* menu. Then pick *Basics > Background* from the *Insert* menu and chose the background image. Click *OK*. The image then appears in the PageBuilder window.

▶▶

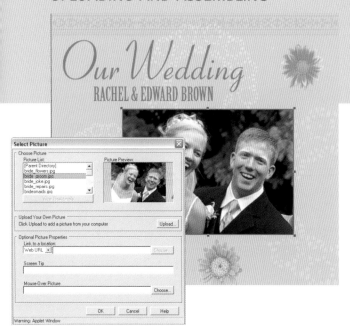

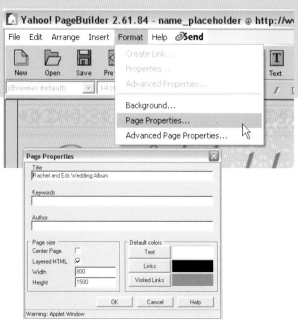

13 Now click on the *Pictures* button and select the bride and groom image from the *User Files* menu. Drag it to the required position.

14 Select *Page Properties* from the *Format* menu and give the page a name. This is the name that appears in the browser. As it is not a file name, spaces are allowed. In the *Page Size* box, check *Layered HTML* (this enables image overlaps) and increase the *Width* to 800 pixels. This is the width visible in the PageBuilder window.

15 The extra width is now visible. Use the *Text* button to create new text blocks and write the description below the photo. We used Times Roman Italic 14 (+1) size in white. For the navigation list on the left, we used Arial Bold 10 (-1) size in black. Save this page with the name 'index'.

16 From the *File* menu, select *Save As* to make a copy of the page and name this one page 2. Repeat the process, this time saving it as page 3. Although we have seven links in the navigation list for this workthrough, we have created only three pages. You can create as many pages as you require using this method.

UPLOADING AND ASSEMBLING

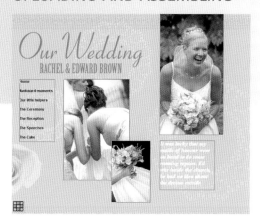

17 Open page 2, which you have just created. Insert the new images and text. We have overlapped two of the photos. When you have finished page 2, save it and then open page 3. Repeat the process of adding images and text. If you are unsure which page you are editing, the file name appears bottom left of the PageBuilder window.

18 The overlap is dictated by the order in which you insert the images. If you wish, this can be changed. Select the image that you wish to be on top and then choose *Layer Order* from the *Arrange* menu.

19 The final task is to add links to the text of the navigation list. First select the text. Then click the *Link* button and choose *My Page*. From the *Pick File* palette, choose the appropriate page and click *OK*. This process will have to be repeated for each link on each page. Don't forget to save the page each time before you open a new one.

20 The final result as the three pages appear in the browser. The frieze can just be seen again at the bottom of each page. This is due to the tiling of the background image.

25

a holiday website

For this project to create a holiday website, we're going to reuse material that was created for the holiday album on page 64.

If you haven't already done so, you should download the master file templates Vacation Album Plain.psd from the web-linked website (*see page 166*). By creating both a print- and screen-based version of your holiday, you are getting the maximum mileage out of those holiday snaps. We have also included a simple animation that you can easily recreate using the image that we have provided. Alternatively, you could use your own.

CREATING THE INTERFACE

① Open a new document in Photoshop Elements at a size of 1000 x 630 pixels. This will be used to assemble the various items for the website. Next, open the 'vacation_album_plain.psd' document and follow the steps in the box on page 152 to create the Web-optimized 'web_vacation_album.psd' template. Change the background colour to a mid-blue.

② Move the 'web_vacation_album.psd' window so that it partially obscures the new document. From the *Layers* palette, select the layer named 3 Panel Plain. Click on any part of the three white-bordered panels and drag from the old document to the new. Make sure that you do not release the mouse button until you are above the new document.

③ Now select the layer named Border Plain. Using the *Magic Wand*, click inside the lighter blue border to make a selection. Select the *Move* tool from the *Tools* palette, and drag the selected box from the old document to the new, just as you did in the previous step. Don't try to drop it in the correct position; this can be changed later. Make sure the *Magic Wand* tool is not still selected when you do this, or you will be dragging the *Marquee* selection only.

④ Move the two new layers into position, making sure the blue panel is now below the white-bordered panels. Paste in a photo that you want to use on the home page. Scale it so that it slightly overlaps the blue panel. Hide the photo layer. Reselect the blue panel layer and, using the *Magic Wand*, click on the darker blue area to select it. Next, click on your photo layer to select and reveal it. Hit *Delete*, and the unwanted parts will be removed, leaving the photo with rounded corners. ▶▶

CREATING THE INTERFACE

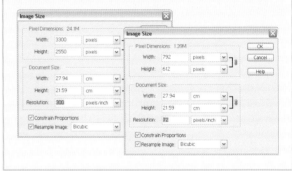

RESAMPLING AN ELEMENTS FILE

To make 'web_vacation_album.psd', open 'vacation_album_plain.psd'. Since the latter was created for a print project, we need to alter it for Web use. Select *Resize > Image Size* from the *Image* menu. Change the resolution from 300ppi to 72ppi (the width will reduce to 792 pixels). Ensure that both the *Constrain Proportions* and *Resample Image* boxes are checked. Select *Save As* from the *File* menu and call it 'web_vacation_album.psd'.

Around the World with Gina Davis

5 Press Ctrl+D to deselect the selection. Paste in the two smaller photos on a layer below the white-bordered panels. Rescale them so that they fit. There is no need to trim them to fit exactly, as the white borders will hide the corners. Create a new layer for the title. We used a white colour and the font Stacatto, as it has a casual feel appropriate to the theme.

SAVING IMAGES FOR WEB USE

6 Ctrl+click on the white-bordered panels layer in the *Layers* palette to select its contents, and choose *Copy* from the *Edit* menu. Now select *New* from the *File* menu and paste the image into the new document. Turn off the background, and the chequerboard shows the transparent areas. Select *Save for Web* from the *File* menu and choose *GIF* from the *File*

Format drop-down. Make sure the *Eyedropper Color* is set to the colour that you will be using for your background. We used blue, set to R 72, G 124, B 215. Transparency should be checked so that the photos that will appear behind the white border and will show through the 'window'. The *Matte* selection should be *Eyedropper Color*. Click *OK*. We named this file 'panels.gif'.

7 Use the *Rectangular Marquee* tool to draw a selection around the title. Use *Copy Merged* from the *File* menu and paste into a new document. Select *Save for Web* from the *File* menu and choose *GIF*. *Transparency* can be unchecked; *Matte* set to *None* and *8 Colors* will suffice. Click *OK*.

8 Select the layer containing the image pasted into the document in step 4. Copy and paste it into a new document. Turn off the Background. Select *Save for Web* from the *File* menu and choose *JPEG*. Once again, select *Eyedropper Color* from the *Matte* menu. This fills the space outside the rounded corners with the background colour. The *Quality* value will be fine at 40, but, as the file is still quite large at 28KB, check *Progressive*. This allows the image to appear in stages when viewed over a slow internet connection. Then click *OK*.

9 Now select the first of the small photos to appear behind the white-bordered panels. Copy it and paste into a new document. Select *Save for Web* from the *File* menu and again choose *JPEG*. As this is a simple squared-up image, we don't need a Matte. As the image will be small, *Progressive* can be unchecked. Once again, the *Quality* setting is *40*. Click *OK*. Continue copying, pasting and saving for Web all additional photos that you plan to use in this project.

UPLOADING AND ASSEMBLING WEB PAGES

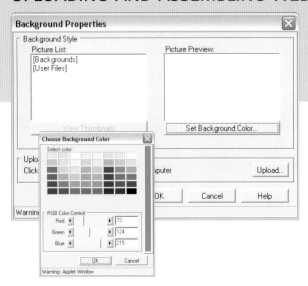

10 Connect to the Internet and sign in to Yahoo! Geocities PageBuilder, as described in a previous projects. When the PageBuilder page displays, select *Background* from the *Format* menu and click *Set Background Color*. This is an alternative to using an image on the background. Select the colour. Here, we used R 72, G 124, B 215.

11 Select *FileManager* from the *File* menu. With the *Images* tab selected, click the *Upload* button. Click *Browse* to select the image files saved above. When all the files have been uploaded, return to the main PageBuilder window. Click on the *Pictures* button. From the *User Files* list, select panels.gif. When it appears, drag it to the right position.

12 Continue by adding the two smaller photos and drag to positions on top of the white-bordered panels. They will appear above the panels. Click on the *Order* button to toggle the stacking order until the white borders appear above the photos.

13 Click on the *Text* button and move the resulting text box to a position within the central white border. Type in the text. We used Arial at size 12; a sans serif font is more readable in this situation.

Continue adding the title and the main image plus the navigation arrows *(see box)*. When you are satisfied with the design, select *Save* from the *File* menu. To create duplicate pages on which to base the additional pages, use *Save As* from the *File* menu and name each one. For the purpose of this workthrough, we have created only two pages.

This is the final result as it appears in the browser. Links have been added to the arrow buttons (described in detail in the previous project). The animated ball moves from left to right, rotating as it does so. At its rightmost point, it touches the arrow, which turns momentarily white.

creating an animated navigation button

Elements can be used to create simple animated buttons. We used the beach ball from page 64. It was copied using the Elliptical Marquee tool to create a circular selection around it and then pasted into the new animated button document. As it was too large, it had to be rescaled to fit.

❶ Open a new document in Elements, 110 x 37 pixels at 72 pixels/inch. Paste the ball in and rescale it to fit. Move it to the left. Duplicate this layer three times. On each of the new layers, move the ball progressively to the right. Select *Rotate > Layer 90 degrees Right* from the *Image* menu. Apply once to the second layer, twice to the third layer and three times to the fourth.

❷ Using the *Paint Bucket*, fill the transparent area of each layer with the webpage background colour. We used R 72, G 124, B 215.

❸ Using the *Polygonal Lasso* tool, define an arrow head. On layers 1, 2 and 3, use the *Paint Bucket* to fill with a blue to match the lighter blue in the ball. On layer 4, fill with white.

❹ Select *Save for Web* from the *File* menu and choose *GIF*. Select *Diffusion* from the *Dither* menu. Dithering helps to compensate for the lack of colours that are set to 30. Make sure that you check *Animate* and *Loop*. You can check the animation frame by frame using the arrows at the bottom of the palette. Click *OK*, and the image will be saved as an animated GIF.

❺ Finally, create an arrow facing the opposite direction (back). Using *Save for Web*, save this as a normal GIF, as it is not animated. Remember to upload these files to PageBuilder along with those described in step 12.

reference

We started this book using the description of a shoe box as the place where many conventional photographs end up. I hope that by now you have been convinced that your digital photo collection should not share the same fate. There are so many ways to present digital photos and, of course, to share them. This section describes some of the options available, as well as showing you some of the borders you can download from the website. Also in this section we've listed websites that we think would be useful and tips on how to mount and frame your images if you want to display them.

CHAPTER CONTENTS

online communities and groups

Online communities enable people with common hobbies, pastimes and interests to share them with others. You may enjoy growing cacti or coaching a local basketball team, for example. Sharing your knowledge and opinions and, in particular, your photographs online can be rewarding and worthwhile. As there are existing communities for the majority of activities, most people join one of these. If you prefer, you can create one from scratch. Most groups include facilities like chat rooms and message boards, but you need only participate in the areas that are of interest to you.

Microsoft's MSN Groups is probably the largest online community and offers free space on its website. After you have registered, you can upload your photos into an online album that is visible to all. If you create your own group, you can stipulate how access to it is granted. MSN Groups offer three categories of access:

Public: Anyone may view and become a member of this group without the permission of the manager.

Public Restricted: Anyone may view this group but needs to be approved by the manager to join.

Private: No one can view this group without first applying and being approved for membership by the manager.

A private group allows you to restrict access to friends and relatives, if, for example, you wanted to collaborate on a family history photo album.

There are other online communities like AOL Groups and Yahoo! Groups, which offer a similar experience to MSN. Many photography manufacturers also have sites dedicated to sharing photos online.

A TYPICAL ONLINE GROUP

▲ The MSN Groups home page shows the group(s) that you have already created (My Groups), along with a list of categories for other groups that you might be interested in visiting or joining.

▲ The Lifestyles group includes a Hobbies and Crafts section, of which Photography is most popular. The Homes and Families Group includes Family Photos and Pets.

▲ We set up our own group dedicated to our new golden retriever puppy called Monty. We have chosen to make this a public restricted group so that anyone may view Monty's photo album.

▲ Within the Photography Group is the popular digital photography club, where members can share their online photo albums.

▲ As we are the managers of the 'Monty our puppy' group, we can administer our photo album, adding new photos as Monty gets older.

professional printing options

There are a variety of professional printing services available; each one serves a particular need. You can upload your photos to an online printing service and have the prints mailed back to you in a few days. Alternatively make a CD of your photos and take it to your local developers or give them your camera's memory card, where they will print them out, usually in a few hours. This service is similar to conventional photo printing, but without the film. You may want to have a t-shirt printed professionally, or perhaps a large poster. These services are also available from online suppliers.

To get the best out of any paid-for service, it is most important to supply the photos correctly. They should normally be JPEG format and any photographic enhancements made beforehand (see pages 26–37). The size of your original photo will dictate the maximum print size (see chart). Do not use the Save for Web option to optimize your photos, as this is reserved for images that will only appear onscreen. Simply use Save As and select JPEG. Choose Maximum Quality (12) with otherwise default settings. If your original photos are high-quality, they can of course be used straight from the camera.

A list of online printing providers is given on page 167.

getting technical

Photos size options

Image Resolution In pixels	Maximum Print Size Very Good Quality	Maximum Print Size Best Quality
512x384	Wallets (2.1" x 3.1")	Wallets (2.1" x 3.1")
640x480	3.5" x 5"or 4" x 6"	Wallets (2.1" x 3.1")
800x600	5" x 7"	3.5" x 5"
1024x768	8" x 10"	4" x 6"
1152x864	8" x 12"	5" x 7"
1536x1024	11" x 14"	8" x 10"
1600x1200	11" x 14"	8" x 12"
1712x1368	16" x 20"	11" x 14"
2048x1536	20" x 30"	16" x 20"
2400x1800	20" x 30"	20" x 30"

ONLINE PRINTING SERVICES

▲ A provider like Printroom.com allows you to upload photos and then select from a range of special printing options.

▲ You can store your photos indefinitely using this facility so they can be viewed online. You can also use the printing service when you wish.

▲ Fuji offer all the options: you can upload photos for online printing; drop off to a local photo print store, or use their Aladdin kiosk to add borders, add colour, crop pictures, and rotate shots before ordering the prints.

▲ Providers like anyTime Photo are independent of the large photographic conglomerates, but offer a similar service, storing and printing your photos.

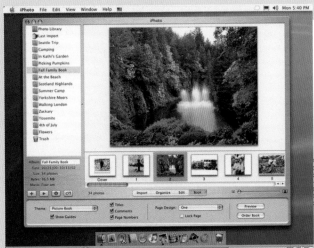

1-Click Photo

| Import | Organize and Archive | Enhance | Make a Book | Share Online | Prints |

As the majority of consumers bypass traditional film cameras in favor of digital photography, an impressive number of them have insisted on being able to continue to enjoy one of the few remaining benefits of film — the ability to order prints. And here too, digital photography has a significant advantage over film: it gives you the option to order high-quality prints selectively (that is, having prints made only of those pictures that turn out the way you like).

Convenient prints

Apple recognized this phenomenon early on in the digital revolution, which is why iPhoto users have always been able to order glossy prints and professionally-bound photo albums directly from the application. And now iPhoto 2 comes with even more printing and print-ordering options.

Fact is, if you have a color printer, you can print high-quality photos right from the comfort of your own home. iPhoto enables you to output high-quality color prints in a variety of standard photo sizes and formats, including custom greeting cards and contact sheets, right to your printer. iPhoto 2 provides an easy to follow menu of printing presets — such as Glossy-Normal and Matte-Fine — for many popular inkjet printers, making printing great photos as simple as choosing from a few standard settings and hitting the Print button. And because iPhoto 2 comes with additional printing templates — yes, even in the perennially popular

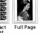

iPhoto in action

Order Prints - Ord prints from Kodak delivered in One-C

Printer Compatibility

iPhoto supports digital cameras from the companies listed below a list of which models a supported, check out th printer compatibility pa

» Apple
» Canon
» Epson
» HP
» Lexmark
» Xerox/Techtronix

Contact Sheet | Full Page | Gr

▲ Nearly all the online services are available to either PC or Mac users. However, Apple offers a service that is, at the time of writing, available to Mac users only, as it is accessed using the iPhoto application. Mac users might prefer it even though the service is limited.

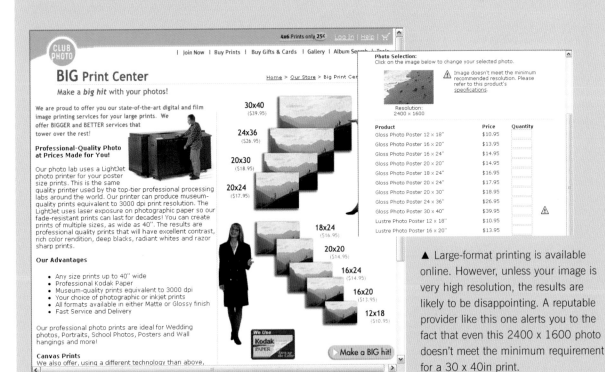

▲ Large-format printing is available online. However, unless your image is very high resolution, the results are likely to be disappointing. A reputable provider like this one alerts you to the fact that even this 2400 x 1600 photo doesn't meet the minimum requirement for a 30 x 40in print.

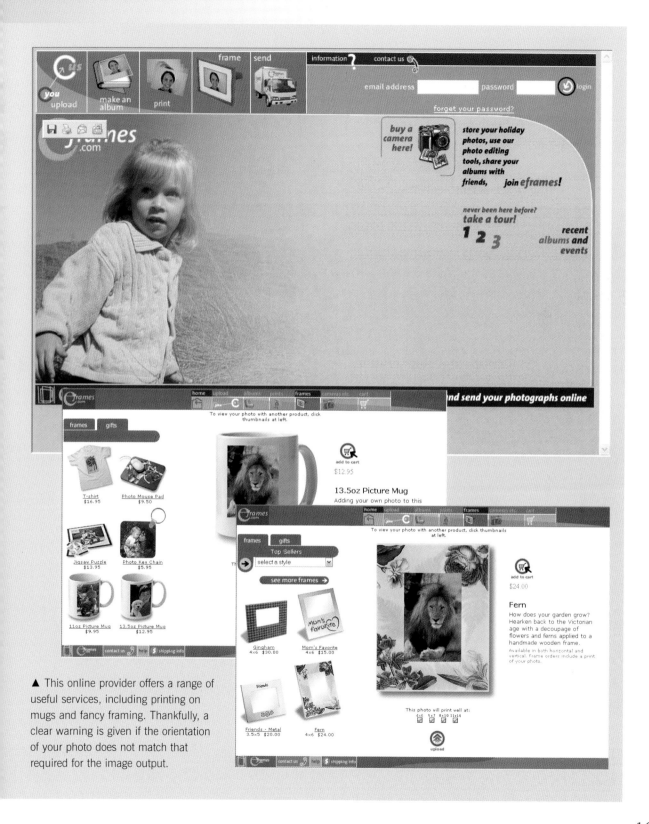

▲ This online provider offers a range of useful services, including printing on mugs and fancy framing. Thankfully, a clear warning is given if the orientation of your photo does not match that required for the image output.

borders and backgrounds

In addition to the images that we have provided, borders and backgrounds can be found everywhere. You could use greetings cards, wrapping paper, wallpaper, packaging, old books and magazines, or scanned objects like leaves, doilies or lace. There are books that provide royalty-free scannable images for domestic use. Clip art supplied with some software packages and the Internet are also useful sources. Applications like Photoshop Elements have tools to create repeat patterns and decorative borders.

The images on this page can be downloaded from our web-linked.com site; see page 166 for the specific URL.

If you prefer to scan from this page, set the scanner to greyscale, scale to 100% and resolution 600ppi (dpi).

useful Web links and reference

We hope that *How to Show and Share Your Digital Photographs* has provided inspiration as well as instruction, and that you are now about to take advantage of the myriad of service and information providers that are available on the Web. The links listed here are all available from our web-linked site, so you do not need to type them into your browser. The site address is **www.prdpuk.web-linked.com** – and here you'll also find all the templates referred to in various projects.

Digital photo printing services

UK and Europe	Web address
Bonusprint, Borehamwood, Herts., UK	www.bonusprint.com
BTopenworld Digital Printing Service (British Telecomm. PLC)	www.btopenworld.com/create/digital_printing
Colourmailer.co.uk, UK	www.colourmailer.co.uk
Comet Digital Photo Printing Service, Hull, UK	www.comet.co.uk
dabsxpose.com, Bolton, Lancashire, UK	www.pixology.com
John Lewis Direct, London, UK	www.johnlewis.com
PhotoBox Limited, London, UK	www.photobox.co.uk
Konica Digital Photo Service, UK	www.konicaphoto.co.uk
Topfoto Services Ltd., Cornwall, UK	www.topfotoservices.co.uk
Fahyfoto.com, Galway, Ireland	www.fahyfoto.com
PhotoBox Ireland Ltd., London, UK	www.photobox.ie
Photosframed.com, Patrickswell, Limerick, Ireland	www.photosframed.com
Photoweb.ie, Dublin, Ireland	www.photoweb.ie
AGFAnet Print Service	www.agfanet.com
Colormailer.com, Vevey, Switzerland	www.colormailer.com
Photocolor Kreuzlingen AG, Kreuzlingen, Switzerland	www.photocolor.ch
PhotoPrintOnline (Bilderland GmbH), Graz, Austria	www.photocolor.ch
RevelaOnline, Salamanca, Spain	www2.revelaonline.com

Specialist printing services

4canvas – **www.4canvas.co.uk**

Eshirt wear your ideas – **www.eshirt.it**

Online Photo sharing services

AGFAnet Slideshow Here's how it works – **www.agfanet.com**

Freeserve Photos - Online sharing and printing

– **http://photos.freeserve.com**

Fuji DigitalCameraDeveloping.com

– **www.digitalcameradeveloping.com**

Kodak Online album with digital pictures – **www.kodak.com**

MSN Photos - More Useful Everyday – **http://photos.msn.com**

Sony ImageStation – **www.imagestation.com**

Subscription Central - MSN Photos Plus – **http://join.msn.com**

Online digital photo paper and supplies

Arts and Crafts Ink Jet Materials

– **www.paper-paper.com/arts&crafts.html**

Avery Office Products – **http://www.avery.com**

Crafty Computer Paper for any craft project

– **www.craftycomputerpaper.co.uk**

M Tech inkjet supplies – **www.mtech-direct.co.uk**

McGonigal Paper & Graphics – **www.mcgpaper.com**

Online printing advice and reference

Online printing expert – **http://online-printing-expert.com**

Digital Imaging Florida University – **www.fsu.edu**

Envelope sizes – **www.envelope.org**

EXIF.org - EXIF and related resources – **www.exif.org**

Folex AG - match printer to paper – **www.folex.ch**

The Myth of DPI

– **www.rideau-info.com/genealogy/digital/dpi.html**

Digital cameras and scanner information

Digital Cameras on creativepro.com – **www.creativepro.com**

Scanner Reviews – **www.imaging-resource.com/scan1.htm**

DP review – **www.dpreview.com**

The Imaging Resource Guide to Desktop Scanners Article

– **www.imaging-resource.com/arts/scang/scang.htm**

Professional digital photographers

Photoworks – **www.photoworkshop.com**

The Luminous Landscape – **www.luminous-landscape.com**

Web page builders and image galleries

Web Image Gallery Creation Tools

– **http://graphicssoft.about.com/cs/webgallery**

Yahoo! GeoCities – **http://geocities.yahoo.com**

Yahoo! PageBuilder

– **http://help.yahoo.com/help/us/geo/builder**

Yahoo! PageBuilder and Basic Page Construction Help Site

– **http://www.yahoopagebuilderhelp.com**

Yahoo! PageBuilder – **http://geocities.yahoo.com/v/pb.html**

Yahoo! SiteBuilder – **http://webhosting.yahoo.com/ps/sb**

Link to sample site home page

– **http://www.geocities.com/name_placeholder**

General

Community Report – **www.onlinecommunityreport.com**

trimming, mounting and sticking

Although this book is primarily concerned with digital solutions to the presentation of your photos, there may come a time when old-fashioned cut-and-paste will provide just the finishing touches that you need. By pasting together prints, you will be able to breach the size limitations of your desktop printer. Why not try a Hockneyesque montage of overlapping prints, or a panoramic montage that is pasted together rather than digitally stitched?

You can also stick your digital images directly on to household surfaces. For example, you could put a puppy border around the nursery wall, or party photos on an old cupboard door. As most inkjet prints are made from water-soluble inks, it is essential to first apply fixative coating spray like Jet Coat. The list below shows some equipment that might be useful. Preparation as well as creativity is usually the key to success.

Cutting
• A craft knife with sharp blade; more accidents occur using blunt instruments than sharp ones.
• A purpose-made cutting mat is preferable, but if you have only a sheet of stout card that will do.
• A steel rule is essential as a guide to cutting straight lines with a craft knife.
• Slender scissors for cutting round shapes; dressmakers' pinking shears for cutting wavy edges.

Pasting
• Adhesive sprays are best for mounting photographs. However, they are not sold in some areas due to the heath risk if they are inhaled.
• PVA water-based adhesive is good for sturdier materials.
• Double-sided tape is effective but doesn't offer a second chance if an element of your presentation is incorrectly placed.
• Adhesive sticks are difficult to control and can leave globules of unwanted glue.
• Glue guns are great for really chunky objects.

Pens and paint
• As most of your imagery will be digital, concentrate on pens that leave a three-dimensional trail, like gel and glitter pens. Nail varnish can also be use to create blobs.
• Acrylic or even oil paint can be used to create a textured surface, but be prepared to allow for the drying time.
• Gold or other metallic paints create a finish that the computer cannot truly replicate.
• Gilt wax can give many surfaces a touch of splendour.

Papers and cards
Often left-over paper can be really effective. Old greetings card can be used for decoupage; doilies are good for decorative borders; and even wallpaper can be used if the pattern is small enough. Tissue paper, marbled paper and various hand-made papers are also useful to have in your creative arsenal.

Miscellaneous
Use a roller rather than pressing glued surfaces together by hand.

framing your photos

Some of the projects in this book demonstrate how a virtual frame can be created directly from software like Elements, or how real-world frames and borders can be either photographed or scanned to enhance your digital photographs. However, there will also be times when you will want to mount your photos in a real frame.

It is sensible to make or purchase the frame (and liner or mat if necessary) first and then to arrange the project so that it fits within the frame when printed. With rectangular frames, this is straightforward, but with some highly decorative frames – for example, an Art Nouveau design – the image may appear behind an irregular shape. If you buy a new frame, it will almost certainly have a sample print inside that can be used as a guide. If this is not the case, try scanning the frame, scale the image to match it and then discard the scanned frame before printing.

If your skills extend to making things, why not buy the mouldings and make the frames yourself? Make sure that you cut the corners with a mitre saw. You could also decorate a plain, unmoulded frame, with sea shells, for example, or your own creations made from modelling clay or salt dough.

A few rules of thumb:

❶ Don't put a project that uses a virtual frame into a real one: frames within frames look a mess. Use a borderless glass frame instead.

❷ Match the character of the image with a suitable framing material; for example, dignified hardwood for seniors; silver for newlyweds; plastic for kids.

❸ Use a multi-opening frame to record events like a wedding or phases of a child's life such as new-born, first day at school, and receiving a sports award or school prize.

❹ Always match the print to the actual frame size. An oversized image shoe-horned into a small frame or a small image lost in a vast frame look equally bad.

glossary

Adobe Inc. Software developer whose products are widely used by professionals and amateurs for many creative tasks such as Web design, graphic design and video editing. Photoshop, Photoshop Elements, Photoshop Album and the video-editing package Premiere are some of its most successful products.

alpha channel While each colour channel defines the level of a certain colour for each pixel, this channel defines the level of transparency for each pixel, allowing you to create images with objects of varying levels of transparency.

anti-aliasing The smoothing of jagged edges on diagonal lines created in an imaging program, by giving intermediate values to pixels between the steps. This is especially common around text.

application Software designed to make the computer perform a specific task. For example, Photoshop is an image-editing application, whereas Windows is an operating system.

artefact Any flaw in a digital image, such as 'noise'. Most artefacts are undesirable, although adding 'noise' can create a desirable grainy texture if an image is appropriate.

back-up A copy of either a file or a program created in case the original file becomes damaged (corrupt) or lost.

bit depth The number of bits per pixel (usually per channel, sometimes for all the channels combined), which determines the number of colours that pixel can display. Eight bits-per-channel are needed for photographic-quality imaging.

bitmapped graphic An image made up of dots, or pixels, such as those produced by digital cameras, scanners and software like Photoshop. It is distinct from the vector images of 'object-oriented' drawing applications.

browser/Web browser Program that enables the viewing or 'browsing' of World Wide Web pages across the Internet. The most widely used browsers are Netscape Navigator and Microsoft Internet Explorer.

burn(ing) The act of recording data onto a CD using a CD burner (a recordable CD drive). Software such as Ahead Nero (PC) or Roxio's Toast (Mac) is often used for this task.

byte Eight bits. The basic data unit of desktop computing.

CCD (Charged Coupled Device) The name given to the component of a digital camera which 'sees' and records the images, like film does in a traditional camera. The CCD is made up of a grid of tiny light sensors, one for each pixel. The number of sensors, and the size of image output by the CCD, is measured in megapixels.

CD-ROM CD (Compact Disk) Read-Only Memory. An evolution of the CD that allows the storage of up to 600 megabytes of data, such as images, video clips, text and other digital files. But the disks are 'Read only', which means the user can't edit or overwrite the data.

CD-R/CD-RW CD Recordable/CD-ReWriteable. CD-Rs are inexpensive disks on which you can store any digital data, or roughly 77 minutes of audio (on a hi-fi CD recorder). But once written and finalized (fixed), the data cannot be erased, edited, or modified. Similar to the above, CD-RW disks can be 'unfinalized' then overwritten, in part or entirely, any number of times. However, CD-RWs will not play on all CD drives, so they are primarily used for storage.

channel Images are commonly described in terms of channels, which can be viewed as a sheet of colour similar to a layer. Commonly, a colour image will have a channel allocated to each primary colour (red, green and blue in a standard RGB image) and sometimes an alpha channel for transparency, or even an additional channel for professional printing with special inks.

clone/cloning In most image-editing packages, clone tools allow the user to sample pixels (picture elements) from one part of an image, such as a digital photograph, and use them to 'paint' over another area of the image. This process is often used for the removal of unwanted parts of an image or correcting problems, such as facial blemishes. In Photoshop, the tool is called the *Clone Stamp* tool (sometimes known as the rubber stamp).

CMYK The standard primary colours used by professional, or 'process', printing: cyan, magenta, yellow and key (black). These colours are mixed according to 'subtractive colour', meaning that white appears where no colour value is applied.

colour depth See *bit depth*

colour gamut The range of colour that can be produced by an output device, such as a printer, a monitor, or a film recorder.

color picker An on-screen palette of colours used to describe and define the colours displayed and used in an application or on a computer monitor. Color pickers may be specific to an application such as Adobe Photoshop, a third-party colour system such as PANTONE, or to the operating system running on your computer.

compression The technique of rearranging data so that it either occupies less space on a disk or transfers faster between devices or over communication lines. For example, high-quality digital images, such as photographs, can take up an enormous amount of disk space, transfer slowly, and use a lot of processing power. They need to be compressed (the file size needs to be made smaller) before they can be published on the Web: otherwise they take too long to appear on screen. But compressing them can lead to a loss of quality. Compression methods that do not lose data are referred to as 'lossless', while 'lossy' describes methods in which some data is lost.

continuous-tone image An image, such as a photograph, in which there is a smooth progression of tones from black to white.

contrast The degree of difference between adjacent tones in an image from the lightest to the darkest. 'High contrast' describes an image with light highlights and dark shadows, but few shades in between, while a 'low contrast' image is one with even tones and few dark areas or highlights.

copyright The right of a person who creates an original work to protect that work by controlling how and where it may be reproduced.

copyright-free A misnomer used to describe ready-made resources, such as clip art. In fact, these resources are rarely, if ever, 'copyright free'. Generally it is only the license to use the material that is granted by purchase. 'Royalty free' is a more accurate description, as you don't have to pay per copy used.

digitize To convert anything—text, images, or sound—into binary form so that it can be digitally processed. In other words, transforming analog data (a traditional photograph or an audio tape, for example) into digital data.

dithering A technique by which a large range of colours can be simulated by mingling pixels. A complex pattern of intermingling adjacent pixels of two colours gives the illusion of a third colour, although this makes the image appear grainy.

dots per inch (dpi) A unit of measurement used to represent the resolution of output devices such as printers and also, erroneously, monitors and images, whose resolution should be expressed in pixels per inch (ppi). The closer the dots or pixels (the more there are to each inch) the better the quality. Typical resolutions are 72 ppi for a monitor, 600 dpi for a laser printer, and 1440 dpi for an inkjet pritnter.

download To transfer data from a remote computer, such as an Internet server, to your own. The opposite of upload.

DVD (Digital Versatile Disk). Similar in appearance to CDs and CD-ROMs, but with a much greater storage capacity. Although store-bought movie DVDs hold up to 18Gb you can only burn around 4–5Gb on the various home formats. Like CD-R and CD-RW you can get blank disks that can be written once or re-written repeatedly. Unlike CDs, however, there are competing formats that look the same but cannot write to each other's disks. These are DVD-R/RW, DVD+R/RW, and DVD-RAM. When buying blank disks be sure to get the correct sort. The write-once disks from both DVD-R and DVD+R can be read by most modern DVD players so, with the correct software, you can make DVDs of photo slide shows or digital videos at home.

EPS (Encapsulated PostScript) Image file format for object-oriented graphics, as in drawing programs and page-layout programs.

extract A process in many image-editing applications whereby a selected part of an image is removed from areas around it. Typically, a subject is 'extracted' from the background.

eyedropper tool In some applications, a tool for gauging the colour of adjacent pixels.

file extension The term for the abbreviated suffix at the end of a file name that describes either its type (such as .eps or .jpg) or origin (the application that created it, such as .qxp for QuarkXPress files). Extensions are compulsory and essentially automatic in Windows, but not on Apple computers, so Mac users should add them if they want their files to work on Windows computers.

file format The way a program arranges data so that it can be stored or displayed on a computer. Common file formats include TIFF (.tif) and JPEG (.jpg) for bitmapped image files, EPS (.eps) for object-oriented image files, and ASCII (.txt) for text files.

FireWire A type of port connection that allows for high-speed transfer of data between a computer and peripheral devices. Also known as IEEE-1394 or iLink, this method of transfer – quick enough for digital video – is employed by some high-resolution cameras to move data faster than USB.

frame A single still picture from a movie or animation sequence. Also a single complete image from a TV picture.

font Set of characters sharing the same typeface, these are stored by your computer and made available to applications where text is edited. There are two varieties of font; vector fonts like TrueType which can be printed at any size with no loss of quality, and bitmapped fonts which cannot be scaled.

GB (GigaByte) Approximately one billion bytes (actually 1,073,741,824), or 1024 megabytes.

GIF (Graphics Interchange Format) One of the main bitmapped image formats used on the Internet. GIF is a 256-colour format with two specifications, GIF87a and, more recently, GIF89a, the latter providing additional features such as the use of transparent backgrounds. The GIF format uses a 'lossless' compression technique, which handles areas of similar colour well, and allows animation. It is therefore the most common format for graphics and logos on the Internet, but JPEG is preferred for photographs.

gradation/gradient The smooth transition from one colour or tone to another. Photoshop and other programs include a Gradient tool to create these transitions automatically.

histogram A 'map' of the distribution of tones in an image, arranged as a graph. The horizontal axis is in 256 steps from black to white (or dark to light), and the vertical axis is the number of pixels, so in a dark image you'll find taller bars in the darker shades.

HSL (Hue, Saturation, Lightness) A way of representing colours based upon the way that colours are transmitted from a TV screen or monitor. The hue is the pure colour from the spectrum, the saturation is the intensity of the colour pigment (without black or white added), and brightness representing the strength of luminance from light to dark (the amount of black or white present). Variously called HLS (hue, lightness, saturation), HSV (hue, saturation, value) and HSB (hue, saturation, brightness).

hue A colour found in its pure state in the spectrum.

icon An on-screen graphical representation of an object (such as a disk, file, folder or tool), tool, or feature, used to make identification and selection easier.

interface A term used to describe the screen design that links the user with the computer program or website. The quality of the user interface often determines how well users will be able to navigate their way around the pages within the site.

interpolation Bitmapping procedure used in re-sizing an image to maintain resolution. When the number of pixels is increased, interpolation fills in the gaps by comparing the values of adjacent pixels.

ISP (Internet Service Provider) An organization that provides access to the Internet. At its most basic this may be a telephone number for connection, but most ISPs provide email addresses and webspace for new sites.

JPEG, JPG The Joint Photographic Experts Group. An ISO (International Standards Organization) group that defines compression standards for bitmapped colour images. The abbreviated form gives its name to a 'lossy' (meaning some data may be lost) compressed file format in which the degree of compression, ranging from high compression and low quality, to low compression and high quality, can be defined by the user.

KB (kilobyte) Approximately one thousand bytes (actually 1024).

lasso A selection tool used to draw an outline around an area.

layer One level of an image file, separate from the rest, allowing different elements to be moved and edited in much the same way as animators draw onto sheets of transparent acetate.

lossless/lossy Refers to the data-losing qualities of different compression methods. 'Lossless' means that no image information is lost; 'lossy' means that some (or much) of the image data is lost in the compression process (but the data will download quicker).

luminosity Brightness of colour. This does not affect the hue or colour saturation.

mask A greyscale template that hides part of an image. One of the most important tools in editing an image, it is used to make changes to a limited area. In Photoshop Elements a mask can only be applied to an adjustment layer, but in Photoshop masks can be applied to all layers.

MB (megabyte) Approximately one million bytes (actually 1,048,576).

megapixel This has become the typical measure of the resolution of a digital camera's CCD. It is simply the number of pixels on the CCD, so a size of 1280 x 960 pixels is equal to 1,228,800 pixels, or 1.2 megapixels.

memory card The media employed by a digital camera to save photos on. This can be Compact Flash, Memory Stick, SD Cards or Smart Media – all store images which can then be transferred to the computer.

menu An on-screen list of choices available to the user.

midtones/middletones The range of tonal values in an image anywhere between the darkest and lightest, usually referring to those approximately halfway.

noise Random pattern of small spots on a digital image that are generally unwanted, caused by non-image-forming electrical signals. Noise is a type of artefact.

pixel (picture element) The smallest component of any digitally generated image. In its simplest form, one pixel corresponds to a single bit: 0 = off, or white, and 1 = on, or black. In colour or greyscale images or monitors, one pixel may correspond to several bits. An 8-bit pixel, for example, can be displayed in any of 256 colours, a 24-bit pixel (8 bits per channel) can display any one of 16.8 million colours.

pixels per inch (ppi) A measure of resolution for a bitmapped image.

plug-in Subsidiary software for a browser or other package that enables it to perform additional functions, e.g., play sound, movies or video.

PNG (Portable Network Graphics) A file format for images used on the Web, which provides 10–30% 'lossless' compression, or a 'lossy' option. It was created as an alternative to the GIF and JPG file formats, but has not yet displaced either.

RAM (Random Access Memory) The working memory of a computer, to which the central processing unit (CPU) has direct, immediate access. The data here is only stored while the computer is switched on, and more RAM can dramatically improve a computers performance.

raster(ization) Deriving from the Latin word 'rastrum', meaning 'rake', this is the method of displaying (and creating) images on a television or computer screen. It is commonly used to mean the conversion of a scaleable vector graphics image into a bitmapped image.

resolution (1) The degree of quality, definition or clarity with which an image is reproduced or displayed, for example in a photograph, or via a scanner, monitor screen, printer or other output device.

resolution (2) Monitor resolution, screen resolution. The number of pixels across by pixels down. Common resolutions are 640 x 480, 800 x 600 and 1024 x 768, with 800 x 600 the size most Web designers plan for.

re-sampling Changing the resolution of an image either by removing pixels (so lowering the resolution) or adding them by interpolation (so increasing the resolution).

RGB (Red, Green, Blue) The primary colours of the 'additive' colour model, used in video technology, computer monitors and for graphics such as for the Web and multimedia.

ROM (Read-Only Memory) Memory, such as on a CD-ROM, which can only be read, not written to. It retains its contents without power, unlike RAM.

Rubber stamp Another word for a clone tool (see *cloning*).

software Programs that enable a computer to perform tasks, from its operating system to job-specific applications such as image-editing programs and third-party filters.

thumbnail A small representation of an image used mainly for identification purposes in a file browser or, within Photoshop, to illustrate the current status of layers and channels.

TIFF (Tagged Image File Format) A standard and popular graphics file format originally developed by Aldus (now merged with Adobe) and Microsoft, used for scanned, high-resolution, bitmapped images and for colour separations. The TIFF format stores each pixel's colour individually, with no compression, at whatever bit depth you choose. That means they can be black and white, greyscale, RGB colour or CMYK colour, can be read by different computer platforms, but can be very large files. For example, an image of 640 x 480 pixels (just 0.3 megapixels) at 8 bits per channel CMYK (32 bits per pixel) is 1.2Mb.

tile, tiling Repeating a graphic item and placing the repetitions side-by-side in all directions so that they form a pattern.

toolbox In an application, an area of the interface that enables instant access to the most commonly used commands and features. Unless switched off by the user, the toolbox is always visible onscreen.

transparency A degree of transparency applied to a pixel so that, when the image or layer is used in conjunction with others, it can be seen through. Only some file formats allow for transparency, including TIFFs which define transparency as an alpha channel, or GIFs, which allow only absolute transparency (a pixel is either coloured or transparent).

TrueType A type of font or typeface composed of vector graphics which can be scaled up or down without any loss in quality.

USB (Universal Serial Bus) An interface standard developed to replace the slow, unreliable serial and parallel ports on computers. USB allows devices to be plugged and unplugged while the computer is switched on. It is now the standard means for connecting printers, scanners, and digital cameras.

vector graphics Images made up of mathematically defined shapes, such as circles and rectangles, or complex paths built out of mathematically defined curves. Vector graphics images can be displayed at any size or resolution without loss of quality, and are easy to edit because the shapes retain their identity, but they lack the tonal subtlety of bitmapped images. They are used in illustrations for their accuracy and clarity, and employed by Photoshop's text handling and shape tools.

webpage A published HTML document on the World Wide Web, which when linked with others, forms a website. The HTML code contains text, layout and navigational instructions, plus links to the graphics used on the page.

Web server A computer ('host') that is dedicated to Web services.

website The address, location (on a server), and collection of documents and resources for any particular interlinked set of webpages.

Windows Operating system for PCs developed by Microsoft using a graphic interface.

World Wide Web (WWW) The term used to describe the entire collection of Web servers all over the world that are connected to the Internet.

index

acknowledgments

This book would not have been possible without the unstinting support of my family and my dog Monty, along with the professionalism and understanding of the editors at ILEX.

The majority of the images used in the projects were from Photos.com, the best online photo resource around.

Graham Davis